Chris Ware

MONOGRAPHICS

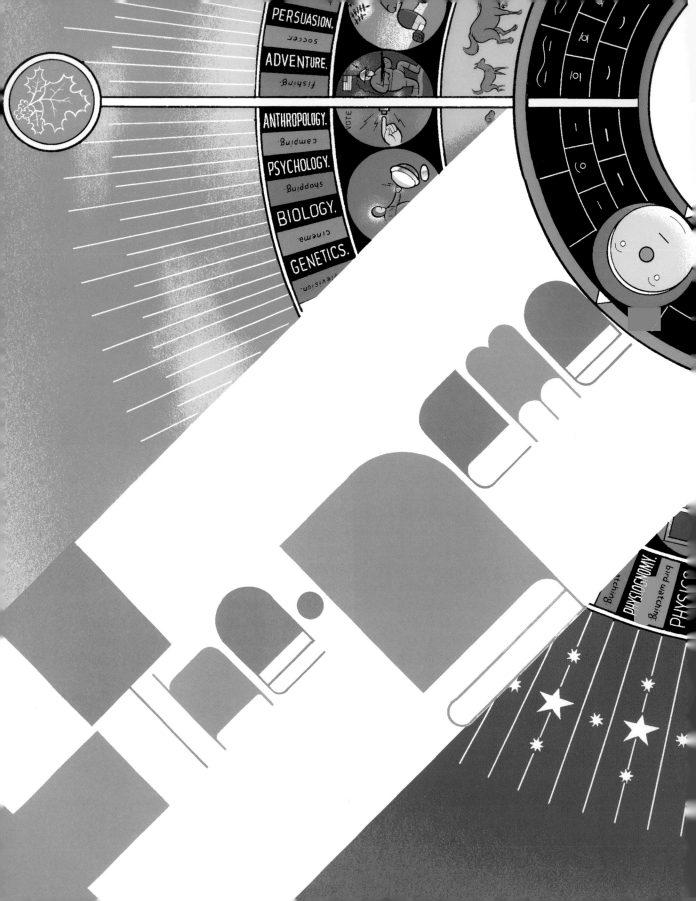

Daniel Raeburn

Chris Ware

Yale University Press

Published in North America by
Yale University Press
P.O. Box 2009040
New Haven, CT 06520-9040

First published in Great Britain in 2004 by
Laurence King Publishing Ltd, London

Library of Congress Control Number:
2004107065

ISBN 0-300-10291-7

Designed by Brad Yendle,
Design Typography, London
Series Editor: Rick Poynor

Printed in China

Frontispiece: detail from the cover of
The Acme Novelty Library number 15,
Fantagraphics Books, Seattle, 2001.

Contents

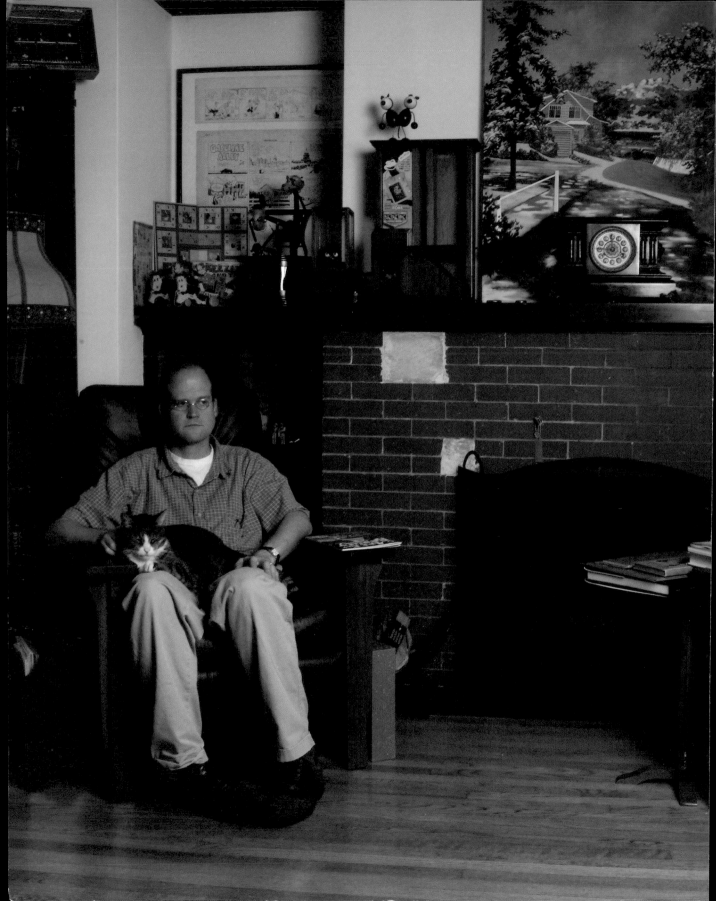

Building a Language

Chris Ware. Photograph by Tom van Eynde, July 2003.

In the 1820s, a Genovese school teacher and essayist named Rodolphe Töpffer began to write in an unspoken and unnamed language. At first it was difficult to say what exactly this language was. Because it was visual, Töpffer decided to call it a language of signs. These signs were hard to define but easy to understand. They were simple enough that all who saw them immediately understood them and anyone, even the untrained Töpffer, could "write" using them. Töpffer derived the internal logic of these signs by studying physiognomy, the then-fashionable practice of judging a person's character by inspecting the shape of their head. Although Töpffer found in this quackery no science, he did discover a mother lode of stereotypes. He drew a series of caricatures to demonstrate that these stereotypes formed the signs, and therefore the basis, of this picture language.

Töpffer was writing in what we now call the cartoon language, the set of culturally ingrained symbols he drew upon when he outlined his characters. Töpffer elevated his insight about caricature to an insight about language by recognizing that the stereotypes did not work alone but in combination. Just as mathematics is powered not by numbers but by equations, and writing is powered not by words but by sentences, Töpffer's "picture-stories" were powered not by individual signs but by combinations of signs working together in sequence.[1] By sensing these interrelations Töpffer detected the pulse of what we now call comics.

Play was the dominant force in Töpffer's art. The words and pictures in his stories did not merely reinforce each other, they also contradicted each other. It was in this lowbrow spirit, drawing with a "a brusque attack ... a clumsy daring that jumps somewhat rudely, with all fours", that the schoolmaster dashed off the first few comics.[2] Before long, Töpffer's friend Frédéric Soret borrowed a couple of Töpffer's whimsies and with another acquaintance, Johann Peter Eckermann, presented them to Johann Wolfgang von Goethe. The dying colossus of German letters was bedridden, suffering from

The Algerines follow the Doctor.

The Live Stock run after the Algerines.

Ducks, Fowls, and Pigeons, join the pursuit.

And the Rats bring up the rear.

The Veritable History of Mr. Bachelor Butterfly
Rodolphe Töpffer
Tilt & Bogue, London, 1845

The popularity of Töpffer's *Histoire de M. Cryptogame*, which ran in the French magazine *L'Illustration*, inspired the London publisher Tilt & Bogue to publish this coloured and unauthorized edition, which they retitled *The Veritable History of Mr. Bachelor Butterfly*. In many ways, Töpffer's comics are more sophisticated than those of the present day; he narrows each successive panel to create the sense that time is passing with increasing rapidity and the animals are therefore moving faster and faster.

inflammation of the eyes and mourning the democracy that had infected his French neighbours. He was also grieving the death of August, his only son. Soret and Eckermann hoped that a couple of Töpffer's picture-stories might be just the thing to brighten the great man's last, lugubrious days. In the Christmas season of 1830 they presented Goethe with Töpffer's *Monsieur Cryptogame*. As Goethe read, his waning eyes glowed and he grew enraptured. Soret and Eckermann hurried to provide him with Töpffer's *Doctor Festus*. As Goethe digested the libretti he repeatedly said to himself, "That is really too crazy," adding, "He really sparkles with talent and wit. Much of it is quite perfect."[3] When Goethe finished relishing the comic books he proclaimed, "If, for the future, [Töpffer] would choose a less frivolous subject and restrict himself a little, he would produce things beyond all conception."[4]

Goethe's review and his prediction have both proved to be omens. Töpffer's art is still a little too crazy for most of his pedagogical descendants. When we compare comics to other arts that were once ignoble but that now wear the gown and mortarboard – the novel, for example, and film – it is obvious that something has retarded the medium's growth. The "comixscenti" insist that snobbery has played a major role in the damnation of comics but neglect to blame cartoonists themselves, who have by and large justified the prejudice

against them. After Töpffer, the majority produced comics that were bad beyond all conception. Only a handful have fulfilled Goethe's auspicious prognostication, and the most recent among them is our subject, Chris Ware.

Along with Daniel Clowes, Robert Crumb and the Hernandez brothers, Ware is a luminary among cartoonists of the so-called underground, adult, alternative or art persuasion. His irregular comics pamphlet, *The Acme Novelty Library*, is a smash hit by the subculture's standards, selling an average of 20,000 copies per quasi-annual issue and earning him every award a cartoonist can win: Eisner, Ignatz, Harvey and Rueben. In 2000, Pantheon Books collected his 380-page *Acme* serial, "Jimmy Corrigan, The Smartest Kid on Earth", and re-branded it not as the comic book it always was, but under the shrewd new rubric of "graphic novel".[5] This comic book, a mind-boggling polyphony of space-time hallucinations and emotional associations centring on loneliness and the birth of the modern world, has sold 80,000 copies to a worldwide audience, most of whom would never set foot in a comics shop. As a result of this marketing breakthrough, Ware has escaped the comics ghetto. He recently purchased health insurance for himself and his wife, Marnie, as well as a three-bedroom dwelling and a used Honda Civic. Given Ware's relatively young age (he was born in 1967) and the fact that he was in his twenties when he created most of the comics now bringing him acclaim, it is clear that he, as much as any other artist, represents the future of comics. But if Ware is the future of comics, he became this future by recognizing a paradox best summarized in the cartoonist Art Spiegelman's aphorism, "The future of comics is in the past."[6]

Take any Sunday funnies page from the 1920s, compare it with any one of today's, and you will see overall a near-catastrophic decay of craft, quality and style. The reasons for this decline are many, but again much of the blame must fall on cartoonists themselves. One of cartoonists' earliest blunders was trying to compete with the cinematic language on the cinema's terms. As the popularity of movies began to eclipse that of comics, more and more cartoonists began to ape a cinematic look and cinematic techniques. In doing so they neglected many of the unique strengths and possibilities peculiar to their own youthful medium, including typography, iconography and page composition. The result was comic strips, then comic books, that behaved less like comics and more like storyboards to a swashbuckling, superheroic action film. These action comics so

dominated the postwar news-stands that to this day they continue to fuel the near-ubiquitous misconception that comics are not a medium but a genre. It is not necessarily the adolescent content of these comics that irks Ware but their adolescent form. "The basic idea of comics is just slapping word balloons on top of drawings," Ware says. "That is so boneheaded."[7]

10 "Krazy Kat"
George Herriman
King Features Syndicate, 1938
© reprinted with special permission
of King Features Syndicate

Ware has borrowed dozens of George Herriman's techniques of composition, but Herriman's greatest influence was thematic: Krazy Kat's unrequited love for the impish Ignatz Mouse inspired Sparky the cat head's tortured relationship with Quimby the mouse.

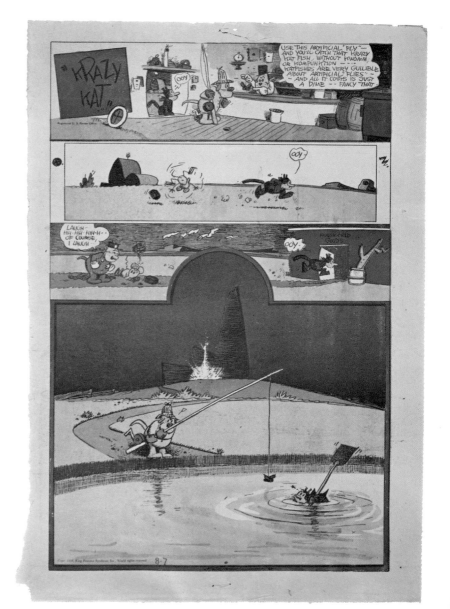

Ware saw the way out of this arrested development not by looking forwards but by looking backwards, before the wrong turns of the 1940s and 1950s. In the early years of the 20th century, artists like Windsor McCay ("Little Nemo in Slumberland"), George Herriman ("Krazy Kat") and Frank King ("Gasoline Alley") laid a broad foundation for the structure of comics, mainly because they were not yet limited by a conventional, concrete idea of what comics should be. Although each artist wrote in the comics language, each invented his own rules for using it, essentially building a visual grammar to fit his world view. "The earliest cartoonists each seemed to have an individual sensibility," Ware says, "an individual take on what they were doing and how they designed the page. The main thing I discovered by looking at the early comics is that there are infinite ways that one can do them."

More than any other young cartoonist, Ware has demonstrated these neglected, infinite possibilities. By recognizing that comics are analogous to a host of other disciplines – including writing, drawing, painting, typography, music, theatre and architecture – and by uniting these arts on the page by virtue of his skill as a graphic designer, Ware has made comics that are truly comic, not only in the humorous sense but in the linguistic sense. He uses Töpffer's strange language so well that he writes comics as much as he draws them, even when his comics contain no words at all. This comic literacy is clearly the result of Ware's intellect and relentless curiosity about the form, as evidenced by his nearly algebraic expositions of the comics language. But it would be unfair to dress our pictolinguistic expert in a black turtleneck and oblong eyeglasses. All of the midwestern fellow's theoretical acumen is the mere by-product of his humble, and more profound, emotions. "I rarely ever did a comic just for the sake of experimentation," says Ware. "Even when I did, I was always trying to get at some kind of feeling." If the comic strip is literally a map of time, and time is the distance between tragedy and comedy, Ware has used his comics to bring the two opposites painfully close. In doing so, he has closed the distance between his life and his art.

Franklin Christenson Ware, boy doodler, became Chris Ware, adult cartoonist, in the only way he could: alone. Because Ware does have a bachelor's degree and because he came within a horsehair of a master's degree he is not, strictly speaking, a self-taught artist. He is, however, a self-taught cartoonist. For reasons sociologists would do

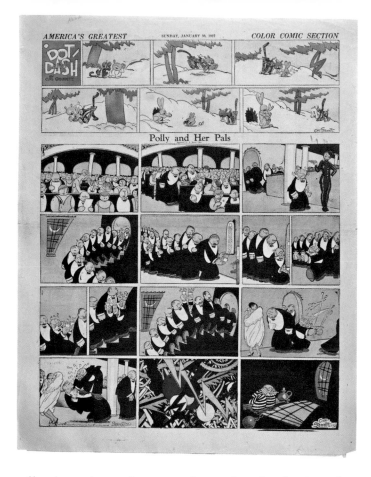

"Polly and Her Pals"
Cliff Sterrett
Newspaper Feature Syndicate, Inc., 1927
© reprinted with special permission of
King Features Syndicate

In his home Ware keeps a framed copy of
this page on display. He says that this strip
originally inspired him to draw comics in
general, and wordless comics in particular.

well to investigate, the cartoonist tends to develop in isolation.
Unfortunately for the health of the medium he is, with few
exceptions, a he and he is generally, like Ware, a nerd whom other
children would rather torment than play with. Rather than put away
his childish booklets, the injured cartoonist retreats deeper into
them, teaching himself how to draw by tracing caped gargantua and
mammiferous witches. After imitation comes adaptation, as the cub
cartoonist modifies these stolen techniques to fit his own peculiarities
and growing obsessions. In the absence of any atelier system or
influential schools he soon develops a unique and startling style that
has evolved in isolation, not unlike a species of fauna confined to one
of the Galapagos Islands. So it was with Ware. By the time he was 20
he had already worked out a recognizable style that prompted Art
Spiegelman to offer him a spot in his legendary comics anthology,
RAW. By the time Ware arrived in Chicago for his graduate studies at
the School of the Art Institute, he was artistically and emotionally
independent enough to ignore his teachers, most of whom
discouraged him from doing comics, and a few of whom openly
mocked him, at least until he dropped out.

Ware continued to steep himself in the comics language by
becoming a tireless historian and curator. He has made his home into
a de facto museum, where he collects and archives the disappearing

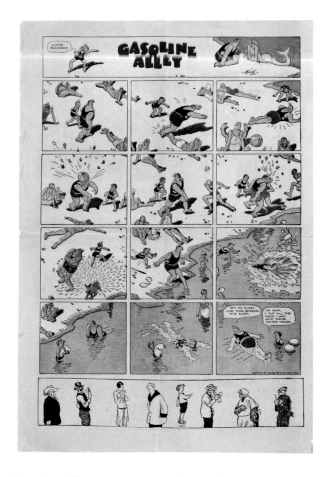

"Gasoline Alley"
Frank King
The Chicago Tribune, 1930

Ware has made much use of Frank King's method of dividing one scene into a dozen different "places" in time.

legacies of past masters, studying these antique comics and stealing shamelessly from them. Take, for example, George Herriman's "Krazy Kat", whose complete full-page strips Ware and Bill Blackbeard have laboured to rescue and reprint. From Herriman's strips Ware learned, among a thousand other things, how to compose an overall page, as well as the way permutations on a single, universal theme – in Herriman's case, a love triangle – can sustain a life's work. The future creator of wordless cartoons first grasped how to use pictorial rhythm to drive a story in a "silent" example of Cliff Sterrett's "Polly and Her Pals". He learned how to transpose space and time visually by swiping the multi-tiered, polyptych panel structure used by Frank King in "Gasoline Alley". "I've always been a parrot," Ware admits. "When I was younger I was always trying to find ways of working that came close to the feelings that I was aiming for. 'Gasoline Alley' changed a lot of my thinking about comics. It made me realize that the mood of a comic strip did not have to come from the drawing or the words. You got the mood not from looking at the strip, or from reading the words, but from the act of reading it. The emotion came from the way the story itself was structured."

As Ware learned about composition from reading other people's comics, he learned something about character from reading his own comics. In 1992, Ware created Jimmy Corrigan as a cipher meant to fit

Jimmy Corrigan, the Smartest Kid on Earth
New City, Chicago, 1 October 1992
Page 22

The *Jimmy Corrigan* book has appeared in
three different incarnations. Originally, it
was a weekly newspaper serial in *New City*,
a free Chicago arts weekly. Years later,
Ware serialized it in the form of chapter-
sized pamphlets in *The Acme Novelty Library*,
and almost a decade after that he compiled
it as one book between hard covers.

At each stage Ware made minor and major
changes to the story, as in this scene,
which he eventually deleted. One could
easily fill a book with the newspaper strips
Ware has never reprinted; unfortunately,
he is too critical of these abandoned
tangents and experiments to let them see
print again.

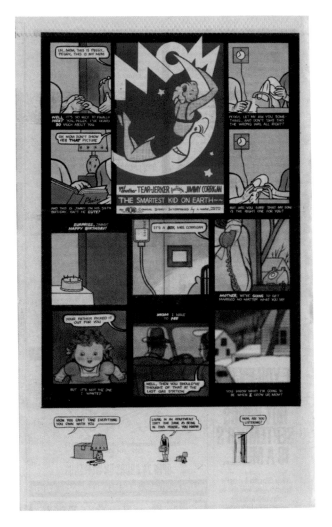

any of his own many moods. In one strip he made Jimmy into an old
grouch; in the next, an irrepressible gee-whiz kid. At the time, Ware
was new to Chicago and had no money, no friends, no girlfriend,
nowhere to go and no way to get there even if he did. (Working late
one night at the School of the Art Institute, Ware broke both his legs
by jumping out of the window after the keepers of the building locked
him inside – a perfect metaphor for Ware's experience of art school.)
Basically, Ware was a lonely schlub on crutches, just like Jimmy. All
of Ware's characters began like Jimmy, as a joke that the legendarily
self-critical cartoonist played on himself. The frump from "Tales of
To-Morrow" parodied Ware's own sedentary pursuit of happiness in

an online consumer utopia; the roly-poly hoarders Rusty Brown and Chalky White lampooned his frenzies of toy collecting. Ware diagnosed this idiosyncrasy as his "Benny Hill" syndrome, because it appears as though one guy – a doughy, bald version of Chris Ware – is playing all of the major roles.

Because Ware cracked these jokes at his own expense, the characters had a reflexivity that soon imbued his stereotypical visions with a humanity he did not at first grant them. When Jimmy Corrigan hobbled out of Chicago to find his fictional father, marking the beginning of his novel and his life as a more fleshed-out character, he ceased to be a cipher and became instead an Everyman. Rusty Brown is no longer the odious flea-market hound but, in the book bearing his name, the same bullied schoolboy that Ware once was. Both Jimmy and Rusty became more specific, more like Ware and oddly more universal. "I don't understand how that happened," Ware says. "I think it's just my immaturity as a writer and an artist, but I'm not able to start out with a specific character. Any time that I start out taking a character really, deeply seriously, it's a miserable failure. Strangely, most of the mean-spirited gags that I've done have ended up being the characters that I truly care about." Ware may begin by caricaturing himself, but in time he turns his caricature into his character.

Art is supposed to imitate life, but in Ware's case the relationship also worked eerily in reverse. When Ware was a toddler his father abandoned him and his mother. Twenty or so years later Ware began to work in earnest on *Jimmy Corrigan*, which begins with Jimmy receiving a letter from the father who abandoned him. The letter requests that they meet. As Ware was midway through drawing out this fictional meeting, his father telephoned him and suggested a meeting. At first Ware thought it was a joke, but it was in fact his real father, and they did face each other, and their conversation was as pained as the imaginary one Ware had already written. The two finished their dinner and agreed awkwardly to meet again some day. Ware went back to work on his book and ended it, years later, with the death of Jimmy's father. Within one month Ware learned that his own father had just died. Ware appended to his novel a corrigendum in which he noted that the four or five hours it takes to read his book is the same amount of time that he had ever spent with his father. The book itself, he concluded, encloses the same quantity of physical matter as the urn holding his father's ashes. By equating his life's

100

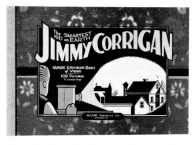

Jimmy Corrigan, The Smartest Kid on Earth,
Magic Souvenir Book of Views
Self-published, Chicago, 1992

With the help of Fireproof Press, Ware self-published these tracts and then peddled them on consignment for $1.25 each in local bookshops such as Quimby's Qveer Store. The pocket-sized format is Ware's nod to the Tijuana Bibles, pornographic comics which were sold under the table throughout North America in the middle years of the 20th century, and the rectangular tracts of the underground Christian cartoonist Jack T. Chick.

work with these human ashes, Ware supplied a grave metaphor for his art, his impetus for creating it and why we might be forgiven for sometimes imagining art to be futile.

Except for a colony of carpers that feeds on internet message boards and the acidic pages of the *Comics Journal*, the comixscenti hailed Ware's singular style of cartooning with a chorus of huzzahs. But cheers made little or no difference. As Daniel Clowes quipped, being the most famous art cartoonist is like being the most famous player of badminton.[8] Ware was still trapped within the endogamous comics industry, which is still breeding superheroes and therefore failing to interest normal bookshops, whose employees cannot decide where to file comic books anyway. For seven years the purblind comic book industry pinned its citations and ribbons on Ware – "best colouring", "best lettering", "best comics-related product" – and every year retailers shelved *The Acme Novelty Library* next to *Elric: Stormbringer* and *Nexus: Nightmare in Blue*.[9] As a result of this ghettoization, Chris Ware remained a cult author through the 1990s.

While a few graphic designers were among the first in the cultural mainstream to extol Ware's strips – Chip Kidd and Steven Heller both wrote substantial and perceptive appreciations of Ware's work in *Print* and *Eye* magazines – most have been less perspicacious, the noxious air of commercialism strangling their judgement. In 1994, a young and literally hungry Ware wrote, designed and illustrated a lucrative 45 r.p.m. record sleeve for the Chicago band 5ive Style; the next year *Print* magazine bestowed on it one of its Regional Design Awards, credited not to Ware – the "illustrator" – but to Jeff Kleinsmith, a staff designer at Sub Pop Records. Ware tries to obviate these sorts of misunderstandings by signing his strictly commercial work with his pseudonym, George Wilson, and emphasizing his less lucrative but self-initiated design jobs, such as his posters, ragtime record sleeves, dolls and curios such as the Rusty Brown lunch box.

The hipper corners of the fine art establishment have from time to time granted Ware their approbation, which is always welcome – not least for fiscal reasons – but the commendation of the art world invariably turns to sniffing. After the Whitney Museum of American Art elected to include Ware in its 2002 Biennial, the *New Yorker* accused the Whitney of "pant[ing] after the youth market" and questioned whether Ware's comic strips were art at all.[10] Such priggery may handicap the comic book's struggle to be accepted as art, but

comics do not belong under the track lighting of SoHo anyway. Comics may be a visual art, but they are an art of writing. Extracting a page from a comic book and putting it behind glass is like cutting a paragraph from a short story and framing it.

The comics language must be used to tell stories that are worth reading; demonstrating that principle is among Ware's most important achievements. The most obvious signal of this came in 2001, when the *Guardian* newspaper in the UK awarded Ware their First Book Award for *Jimmy Corrigan*. This was the first time that a comic book was officially judged on an even playing field against literature and found superior. By refusing to differentiate between comics and prose, the *Guardian* avoided the condescension implicit in the Pulitzer committee's "special" award in 1992 for Art Spiegelman's *Maus* and opened the door for cultural umpires to call comic books what they are: books.

But if comic books now compete with literature, the comics language has some catching up to do. Because slapstick men and action merchants stewarded the language for most of its life, its visual means for expressing emotion, such as shock waves, sweat beads and speed lines, are less like tools and more like clubs. Writing comics can feel like writing using only a hundred adjectives and a thousand exclamation marks. "Comics aren't really a literature," Ware says, "not yet, anyway, mainly because the tools for expressing yourself are still so limited. For example, if somebody wanted to make a film about their life, they probably could. It might not be any good, but because everyone grew up watching movies, everyone is steeped in the language of film, and they could muddle through the process of conveying their intentions. Or if somebody decides to sit down and write their memoir, they can do it. Just look at the size of an English dictionary: We have a huge vocabulary of words and the grammar to express our feelings with subtlety. But whenever you try to write about life using the basic received structure of comics the result ends up generally feeling like a sitcom. The only way to change this is to keep on making comics, again and again, so that the language accrues the means for conveying details and nuances."

Although comics are composed of words and pictures, they are both of these things at once and therefore neither. In his 1990 sketchbook Ware muses, "Comics are first a visual medium – but there's a big difference between 'seeing' and 'reading'." To illustrate this difference, Ware drew René Magritte's painting of an eye paired with

the word "eye". Although Magritte's pairing proves that the picture and the word are different, it also demonstrates that we read them to mean the same thing. Because we can equate them, we can interchange them. This rebus is a key to understanding the art of Chris Ware. Ware notes, "The difference that separates cartoons from visual art and from literature [is] something that is both seen and read simultaneously." He concludes his observation by asking himself, "How to blend these elements effectively?"[11] Ware's first step in learning to blend the two was, paradoxically, to separate them. He began by eliminating words from his strips and forcing his pictures alone to tell the story.

These early wordless strips – we might call them "silent" strips – are a map of the way Ware intuitively worked through the implications of purely visual storytelling. The first thing he learned was that if he were going to make his pictures do the work of words, then the pictures, like words, would have to obey the rules of typography. Just as setting body text in a less ornate typeface makes it more readable, Ware cartooned in a minimal style to make his comics more readable. His strip "Cat Daddy" is an example. The composition is dense, but the relative lack of detail within each panel keeps the readers from lingering for long on any one, enabling them to navigate the narrative maze in relative ease. Wordless workouts like "Cat Daddy" were best for the black-and-white newspaper Ware was then restricted to. Not only did his simple symbols reproduce adequately on cheap newsprint, they fitted into micropanels which gave him the space to run his readers through a longer range of dramatic peaks and valleys, and at a speed that made the ups and downs more emotional. And emotion is what comics are all about, at least for Ware. He rendered his cat and mouse not as drawings but as the barest of symbols to test the way cartoon icons largely bypass the readers' eyes and go straight to their brain, which reads the icons as it would words. In comics, the shortest route to readers' hearts is Magritte's eye for an "eye".[12]

"Fundamentally you're better off using ideograms rather than realistic drawings," Ware says. "There's a vulgarity to showing something as you really see it and experience it. It sets up an odd wall that blocks the reader's empathy." Imagine if for the cover of the fourth issue of his *Acme Novelty Library* Ware had substituted in place of his symbolically weeping cat head a finely detailed close-up of a yowling tabby with wet fur and quivering whiskers, and you see

immediately this wall. Realism is fine for telling tales about jut-jawed good guys in tights who sock dastards, but it is too explicit for anything emotional. It bullies the readers and their emotions, turning sentiment into sentimentality. Just as the old saw holds that in writing fiction you should show, not tell, in comics to show too much is to "tell" too much. Ware kept his pictolinguistic strips simple because his goal was not to depict emotion, but to create it.

As Ware was making pictures act like words he also made words act like pictures, most strikingly in his Quimby and Sparky strips such as "I Hate You" and "I'm A Very Generous Person". In the same ways that a typographer physically transforms the words in display and logo type to make them embody the meaning of the words themselves, Ware transformed the storylines of his strips into headlines, choosing colours, typefaces and the occasional rebus to symbolize the emotions warranted by the words. He then used these headlines to move the story forwards, using typography to tell not only the verbal story but also the visual story. He did this lettering by hand. For years he performed the exercises from old hand-lettering manuals and copied fruit, cigar and cosmetics labels in order to attain a proficiency, then a fluency, in the increasingly antique art of hand-lettering. This fluency is not an aesthetic end in itself; instead it is a way for him to fit more expression, and therefore more emotion, into his comics. "I've tried to teach myself enough about typography so that when I write a word or use a typeface I unconsciously choose a way of writing it, or drawing it, that reflects exactly the feeling that I'm going for," he says. "I don't want to think, Oh, Optima bold would work best here. I want to just start drawing it and have it come out with the right feeling. I want it to be a completely intuitive process. In the same way that when you're writing you search for the right adjective, and it comes up and feels just right – I want to do that with my type."

After separating the two halves of the comics language and driving his way through short strips using primarily one or the other, Ware began to restore a more traditional balance between them. He resumed writing comics such as "Rocket Sam", "Big Tex" and "Jimmy Corrigan", that were for the most part more detailed drawings with word balloons on top of them. But unlike photorealistic characters, who look like actors standing behind cut-out balloons with typed dialogue, Jimmy and company were still cartoony enough to be of a piece with Ware's hand-lettering. Ware was careful to make the word and the image equally legible and meet in the middle of the spectrum

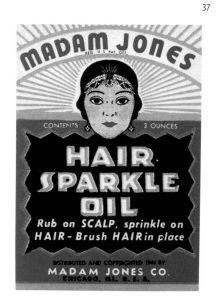

37

Madam Jones Hair Sparkle Oil
Artist, designer unknown
Valmor Products, Chicago Illinois, 1944

Madam Jones was a subsidiary of the Chicago-based Valmor family of African-American beauty supplies, whose typography and design Ware routinely imitated in the headers of Jimmy Corrigan's earliest serial instalments in *New City*.

39

between them. That sweet spot is what makes reading his comics so easy, and making them so hard. Ware tries to hit that spot by again applying the principles of hand-drawn typography to his cartooning. "In order to work visually my comics have to fall somewhere between the general and the specific," he says. "They have to be of a syncretic whole in order for the comic to have any aesthetic conviction or emotional power. But the problem is, as with any form of writing, the richness and texture of the story comes from the specifics, from the details. So I use specific details, but I try to draw the details in a general way, if that makes any sense at all. That's why I 'draw', or cartoon, my comics the same way I do my type. I do all the curves with a brush, I do all the straight lines with a ruling pen. I try to get my pictures to read like words, so that when you see them you can't make yourself not read them, in the same way that when you see a printed word you can't make yourself not read it, no matter how hard you try." In other words, Ware tries to achieve visually what the cartoonist Ernie Bushmiller did with his strip "Nancy". As the legendary cartoonist's cartoonist, Wally Wood, said of "Nancy", it takes more effort to not read the strip than it does to read it.[13]

Then there is colour. For years Ware worked in black and white. After that he was restricted to whatever colours were in the cigarette or alcohol advertisement ganged onto the same printing signature as his *New City* strip. Since the mid 1990s his strips have been in full colour every week and one combination has proved dominant. Ware obviously likes red and blue. There is the red and blue of his Super-Man, or God character, as well as the women of his two comics-in-progress, *Building* and *Rusty Brown*. Now that Ware is married he apparently no longer needs to create each new character as a version of himself. The nameless, one-legged heroine of *Building* bears a remarkable resemblance to Marnie Ware, as does Alice White, the heroine of *Rusty Brown*, particularly because Ware clothes both of his wife's dopplegangers in the same red cardigan, blue school skirt and white knee-length socks his apparently patriotic libido demands. "No," Ware says, turning red. "That's not it. I try to keep all the secondary and muted colours in the background and colour the main character with primary colours. That way they have more vibratory intensity and more of a presence. It almost provides an implicit sense of movement. It's the cheapest trick in colouring." When *Rusty Brown*'s pretentious art teacher, not coincidentally named "Chris Ware", strikes poses for his class in an attempt to sneak a peek up

Alice White's skirt, it is colour that makes the lecherous pedant appear to move. By framing the Chris Ware character's entire figure within each panel Ware creates the same sense of puppet-like animation he achieved in his black and white "Quimby" strips. By adding the alternating background of magenta and orange he makes each pose leap to life.

As with every other tool in his bag of tricks, Ware uses colour not just for colour's sake but as a means to the one end. He is not after motion but emotion. He uses his muted, secondary background colours to warm up his otherwise rather cold, mechanical, typographic style of picture writing. The natural reds, browns and flesh tones give life to the skeletal, black and white structure, as evidenced in the way he builds his *Building* novel. Not only do the colours balance his stark visuals, they can work in counterpoint to his stark content. *Jimmy Corrigan* may be the most physically beautifully book ever written about loneliness. "The book is morose," says Ware, "but I tried to make the pages as beautiful as I possibly could. The colour was essentially an argument counteracting what was going on in the story, because there's no way to say, 'Oh, life is beautiful and wonderful' without sounding corny. You have to show it."

In sum, comics are a map of the fourth dimension, composed not only of the intersection of words and pictures but also of words that act like pictures and pictures that act like words, with colour and composition shaping the map with their own structure and emotional meaning. This requires Ware to be not only a writer, drawer and painter – an illustrator, if you must – but a calligrapher, typographer and, to tie the arts all together, a graphic designer. When we extend the demands of comics from actuality to analogy and consider for a moment that Ware must create a world and portray convincingly every character who inhabits it, it is fair to say that Ware's chosen art also requires him to be a casting agent, wardrobe artist, set designer and actor. In short, Ware has to work like a theatre director. Given that he also has to frame and crop our every view of this world, he also has to work like a cinematographer. He has to be a control freak.

One has to wonder why people shrugged off this confounding art as kid's stuff. One also has to wonder why Ware stuck with it. For 40 to 50 hours a week, every week, for nearly 20 years, Ware has sat at his scarred drawing table composing one page additions to this most disrespected of all mediums. He has done this work in relative

96

isolation, a part of no movement, no school and, until recently, for almost no money. When we consider this grind it is impossible to overestimate the role of grit in Ware's honing of his art. As early as 1990, Ware was bucking himself up with these exhortations: "DON'T GET BITTER", "DON'T STAGNATE", "RESPECT YOUR OBSESSIONS" and the quintessentially Wareian war cry, "VALUE YOUR WORTHLESSNESS". Under these dictums he added, "READ A VARIETY OF THINGS" and, as a final commandment, "DON'T JUST DRAW COMICS!" To this he added, "Keep making stuff, too! Or the above will not be able to happen."[14] Ware's latter two pronouncements and his postscript are a key to his art. By working on arts and crafts that would appear to have nothing to do with his art, Ware enriched not only his own comics but also our understanding of what comics require.

Because comics are a language, drawing comics is just as accurately described as writing comics. If we think of Töpffer's language of physical stereotypes – the cartoon language – as the nouns of the comics language, and speed lines and shock waves and their ilk as verbs, structured by a conventional grammar of panel borders and word balloons, Ware is writing something akin to poetry. Poetry is the tired art critic's analogy of last resort, but the similarities between poetry and comics are undeniable. A comic strip's physical properties form its meaning in the same way that line length, line breaks and onomatopoetic sound shape the meaning of a poem.

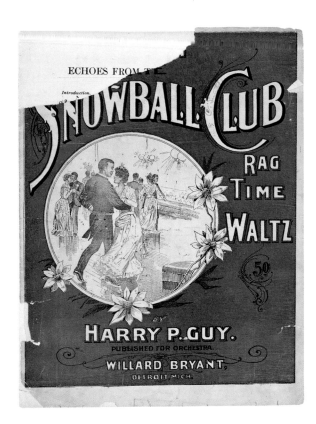

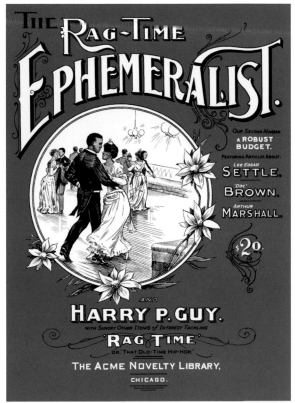

Echoes from the Snowball Club
by Harry P. Guy
Artist, designer unknown
Willard Bryant, Detroit, Michigan, 1899

The Rag-Time Ephemeralist, number 3
Self-published, Chicago, 2001

This issue of Ware's magazine contains
a 37-page article about the African-
American composer, Harry P. Guy.
By way of explaining the swipe, Ware says,
"I don't want the magazine to look like my
stuff. I want it to look like I have nothing
to do with the design of it."

The comparison Ware makes most often is between comics and
music. Like music, comics are composed of divided time. The gutters
between panels mark these divisions and give comics what comedians
call timing, actors call beats and musicians call rhythm. We can
almost feel these silent beats as our eyes alight on panel after panel
and read the character's body language. This visual rhythm is most
noticeable in wordless comics, but if we ignore any captions or word
balloons and scan the pictures only, we can still feel the pulse. When
we do read the words their sound plays off this background rhythm
and creates a kind of melody, and the degree to which the two are
consonant or dissonant makes for a kind of synaesthetic harmony,
what we might call the music of comics.

It is no coincidence that Ware is an accomplished amateur
musician. He not only plays the piano and the banjo, and more
mellifluously than he protests, but he also studies turn-of-the-century
American music as assiduously as he studies early comics. The two
are more connected than one might assume. To date, Ware has edited,
designed and published three volumes of *The Rag-Time Ephemeralist*, his
substantial study of what he calls "that old-time hip hop". Some of the
similarities between comics and ragtime are cultural – both arts were
originally disrespected because of their lower-class origins and are
now ignored because of their later, more popular bowdlerizations.
Some of the similarities are structural, and it is these parallels

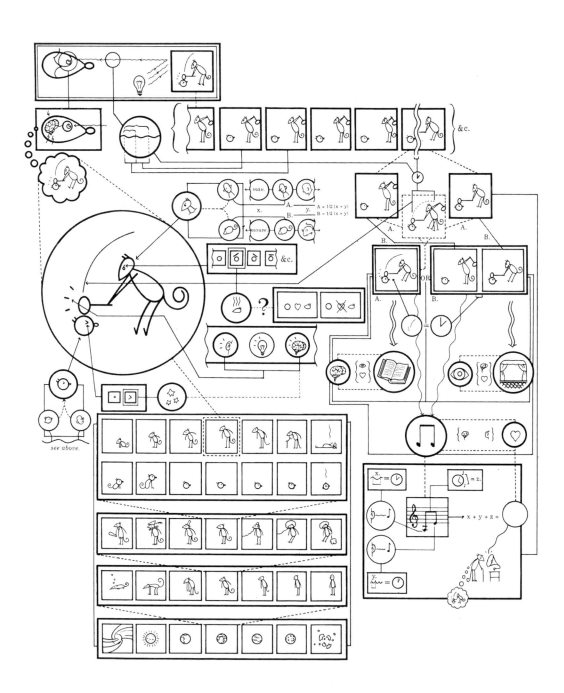

The comics language, illustrated
The Acme Novelty Library, number 6
Fantagraphics Books, Seattle, 1995
[OPPOSITE]

This succinct, almost algebraic dissection
of the comics language diagrams the
language's iconic, theatrical, temporal
and musical properties. At the same time
it also tells the story of Quimby's treatment
of Sparky and of his regret, years later,
for his cruelty.

between the panelled art and the syncopated art that moved Ware.
In the same way that "Gasoline Alley" taught Ware that the feeling
of a comic strip was best built into its structure, so that the mood
emerged from the act of reading it, the best ragtime musicians –
Joseph Lamb, Scott Joplin and James Scott – taught Ware that musical
emotion need not be expressed through performance but through
composition. "Ragtime was this way of composing and encoding
emotion," Ware says, "writing and playing these beautiful, crystalline
structures of feeling, which is really inspiring to me. What fascinates
me about it is that it actually can encode a feeling, which has got to
reflect in some way a natural structure in the universe, as goofy as
that sounds. There's some basic structure there, based on the way that
the world is ordered, that fits intuitively into the way that we see,
and interpret, and are disappointed by the world." Again, it is design
that knits these arts and these analogies together. "Ragtime is a music
of composition and comics are an art of composition," says Ware. "Or
design, since composition and design are essentially the same thing."

Because comics, like music, are composed by dividing time, each
panel is like a window into time, and together these windows form
a map whose chain lets us see the story's beginning, middle and end
simultaneously, at least when the story fits on a single page. In a
longer story, Ware compensates for the page breaks in the composition
by deliberately placing recurring images and visual motifs in an
identical location on their page spread, visually linking parallel
emotions and events in the lives of the Corrigan men. Ware does this
to nudge the memory and help the reader see more of the book at
once. This points out what we might call the architecture of comics.

"What you do with comics, essentially, is take pieces of experience
and freeze them in time," Ware says. "The moments are inert, lying
there on the page in the same way that sheet music lies on the printed
page. In music you breathe life into the composition by playing it.
In comics you make the strip come alive by reading it, by
experiencing it beat by beat as you would playing music. So that's one
way to aesthetically experience comics. Another way is to pull back
and consider the composition all at once, as you would the façade of
a building. You can look at a comic as you would look at a structure
that you could turn around in your mind and see all sides of at once."
Ware then murmurs that his explanation sounds "way too pompous,"
but he is, as always, modest to a fault. His architectural analogy is
based in fact. The word "story", meaning a narrative as well as the

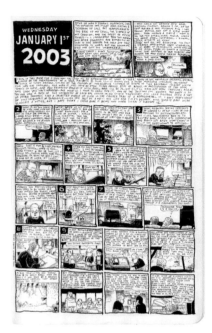

Diary
1–9 January 2003

Every day Ware records his thoughts in
this cartoon diary. This page, chosen by
Ware mainly for its nonvirulent nature,
shows Ware's dedication to his struggle at
the drawing board. The entry for 4 January
was drawn at 3 a.m., after Ware had
already worked for 19 hours straight.

storey of a building, is an etymological fossil that contains a missing
link between narrative art and architecture. As Art Spiegelman has
pointed out, "story" descended from the medieval Latin "historia",
which meant "picture" as well as the horizontal division of a
building. Latin users derived this conflation from the medieval
practice of placing a picture in each window of a building, especially
in churches.[15] A storey was literally a row of coloured pictures.

The germ of this architectural analogy came to Ware in 1995. In
a corner of his sketchbook he copied "ARCHITECTURE IS FROZEN
MUSIC." Beneath it he scrawled, "This is, I think, the aesthetic key to
the development of cartoons as an art form."[16] The author of this key
equation was none other than Johann Wolfgang von Goethe, the first
reviewer of the first comic books. An oddly synchronistic coincidence.
But it is no coincidence that Ware has chosen for his most recent story
the title of *Building*.

Selected Work

28 *Lonely Comics & Stories*
Front cover
Self-published, Chicago, 1992

This is Ware's first collection of comic
strips, which he photocopied and bound
with binding tape and then sold on
consignment at a handful of small
shops. Quimby's fellow diners include
Ernie Bushmiller's Nancy and E.C.
Segar's Popeye.

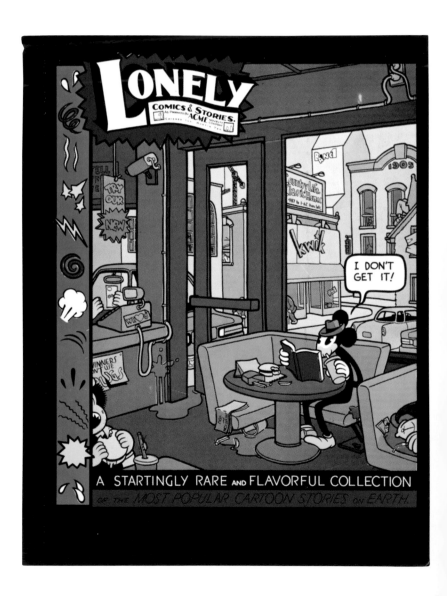

"God"
New City, 21 May 1992
Page 19

Since 1992, Ware's strip has appeared every
week in one of Chicago's free weekly
newspapers, appropriately relegated to
the back along with the lonely-hearts
advertisements. This is Ware's first ever
Chicago strip. Its signature characteristics
make it his prototypical Ur-strip: the red
and blue palette, the use of typography to
mark space and thus time in transition,
and especially God's all-too-human
mixture of cruelty and mercy.

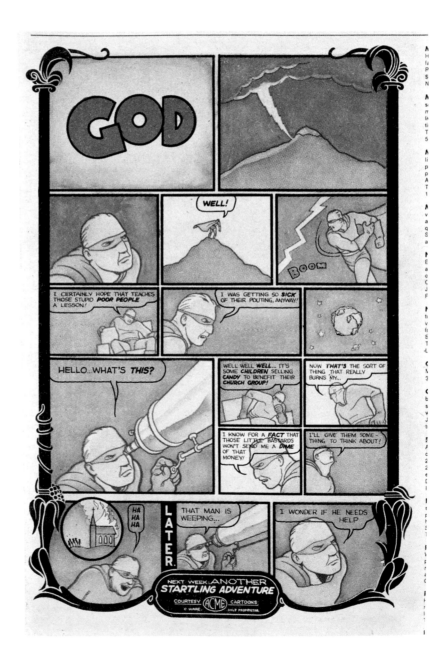

The Acme Novelty Library, number 2
Front cover
Fantagraphics Books, Seattle, 1991

Ware puts words in the centre, which
he usually reserves for a picture,
and puts pictures in the sidebar, which
he usually reserves for words. This
reversal emphasizes that he is treating
cartoon pictures according to the rules
of typography.

30

Quimbies the Mouse
The Acme Novelty Library; from Issue One
Page 7
Fantagraphics Books, Seattle, 1994

When Ware's grandmother was dying, Ware felt as though part of him were dying. Hence the siamese mice, one young, one old and near death. The surviving mouse's memory of finding the soda bottle grows up and out of an already unconventional right-to-left sequence of panels, mimicking the non-linear, associative clusters of memory itself. Also, the surviving mouse's thoughts end prematurely, clipped at the edge by the darkness, whereas the dying mouse's joyful dream is literally open-ended.

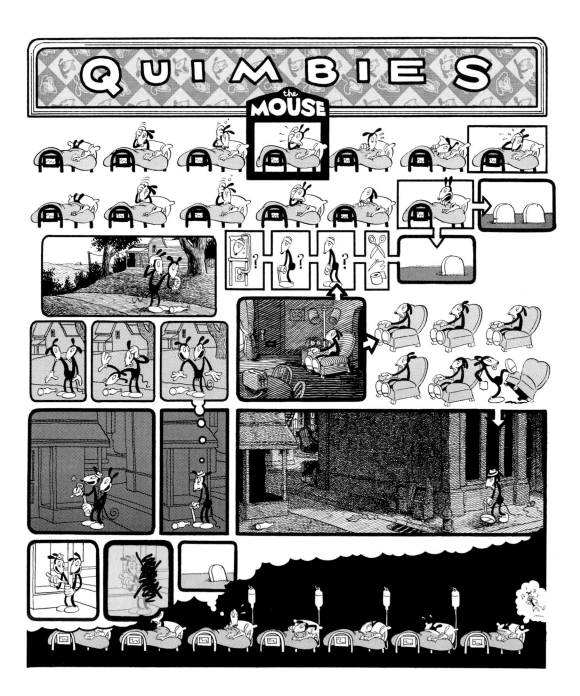

The Acme Novelty Library, number 3
Front cover
Fantagraphics Books, Seattle, 1994

This is as close to minimalism as Ware gets.
The line drawing of his childhood home
in Nebraska, together with the wallpaper
and black binding tape along the spine,
combine to make this book look more like
a handmade scrapbook or family album.

"I stole the wallpaper pattern from a
Snow White and the Seven Dwarves tea
set that was made sometime around 1940,"
Ware says. "God, it's so embarrassing."

32

The Potato Man
The Acme Novelty Library, number 3
Page 29
Fantagraphics Books, Seattle, 1994

Ware drew this semi-autobiographical,
potato-headed character when he lived
in Austin, Texas, and waited for years
before he reprinted it in *The Acme Novelty
Library*. The house is almost identical

to the model house Ware later constructed
from wood (see page 52).

(see page 52).

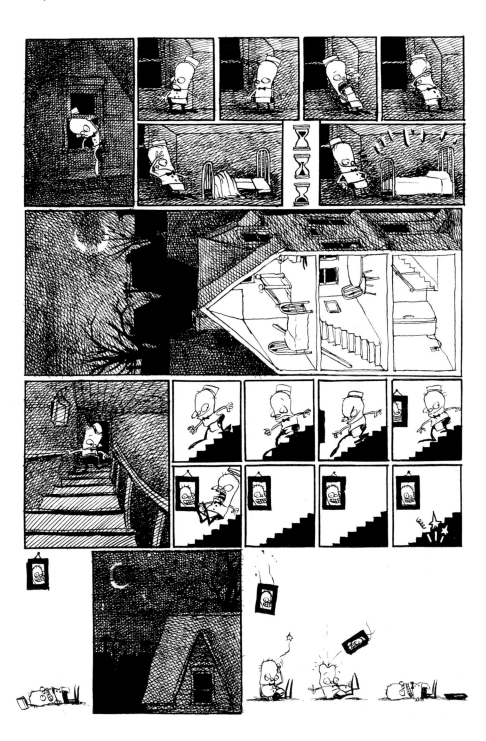

The Acme Novelty Library, number 4
Front cover
Fantagraphics Books, Seattle, 1994

Sparky the cat head was inspired in part by Philip Guston's self-portraits of the 1970s. Ware frames his lugubrious feline with a stage-like arch against a backdrop of stars, a proscenium of sorts he echoes by placing a build-your-own "Théâtre Pathétique" on the inside back cover. The cyan film strip at left shows how the earliest films – which were like filmed plays in that their directors relied on a single, fixed point of view – share this stagey quality with the earliest comic strips.

34

False advertisements
The Acme Novelty Library,
number 4 [LEFT] and number 10 [RIGHT]
Fantagraphics Books, Seattle, 1994 and 1998

Ware's skill as a pure prose writer is
evident in these hilarious, harsh parodies
of comic-book adverts, which he dashes
off to fill unused space in the margins
of *The Acme Novelty Library*. By using this
idiom Ware is continuing a tradition begun
by Harvey Kurtzman, the Moses of

underground comics, in Kurtzman's *MAD*
comic book of the 1950s and continued in
the 1960s and 1970s by Robert Crumb.

"Cat Daddy"
The Acme Novelty Library, number 4
Page 6
Fantagraphics Books, Seattle, 1994

For years Ware drew wordless strips to isolate what he calls the "music" of comics. The amount of detail in a panel determines in large part how long we linger on it. We read the minimal panels so rapidly that they "sound" like notes from a player piano, whereas the more detailed, realistic drawings read slowly, like a long note held. When the relatively cartoony Super-Man crushes the realistic house, the contrasting styles act like multiple notes working together to form a chord.

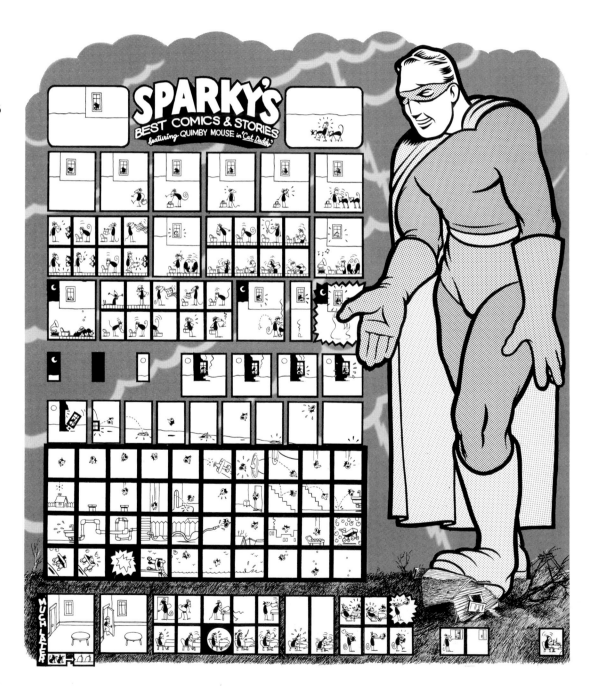

"I'm A Very Generous Person"
The Acme Novelty Library, Number 4
Page 14
Fantagraphics Books, Seattle, 1994.

Ware not only reduces pictures to the level
of words, he elevates words to the level of
pictures. He runs Quimby's fib, "Yeah, I'm
sort of busy right now", backward to show
that Quimby is lying. The composition is
built on typography just as the mice's
relationship is built on lies.

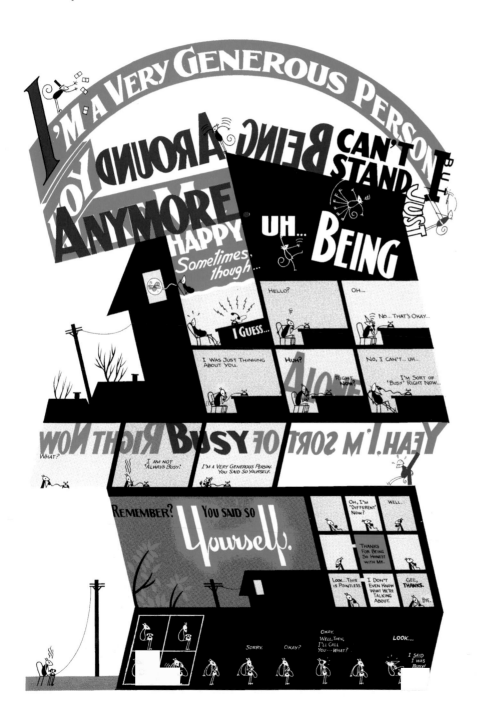

37

38 *The Acme Novelty Library*, number 7
Front cover
Fantagraphics Books, Seattle, 1996

Ware sets his sedentary robot within a central porthole in order to visually link the book with the bulbous television set beside the robot's easy chair. The arch sophistication of Ware's writing and his typography run circles around this visual pun, giving the lie to Ware's facetious suggestion that his comic book is as base and brainless as that most passive of mass entertainment devices. Ware took the playful aspect of the cover a step further by swiping these colour patterns from an old board game.

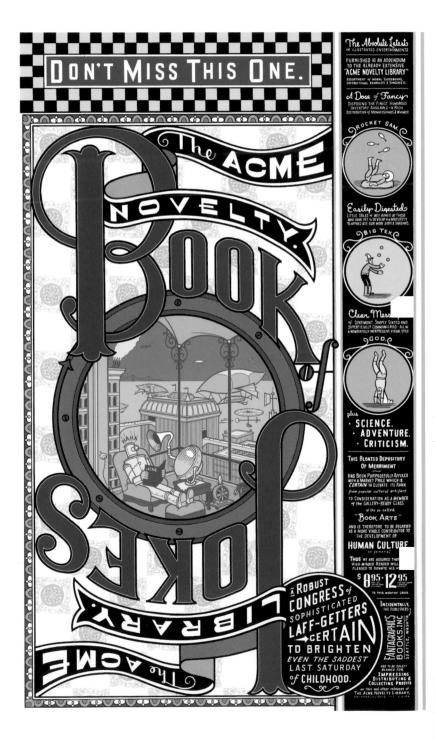

"Big Tex"
The Acme Novelty Library, number 7
Page 28
Fantagraphics Books, Seattle, 1996

This strip allows the reader to see one tree
– one space – at fifteen different points,
or spaces, in time, literally capturing the
distance between comedy and tragedy.

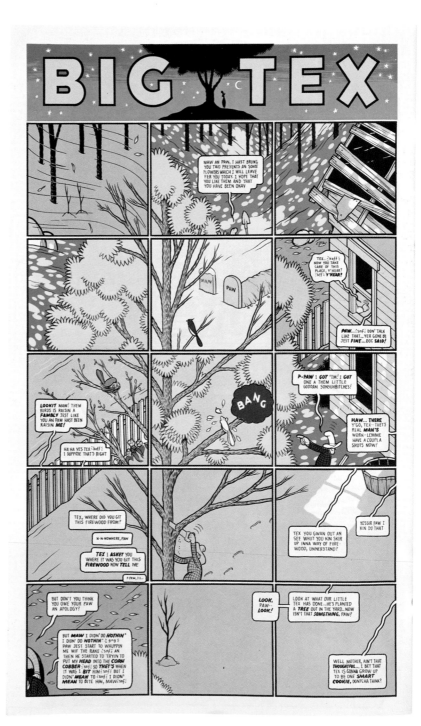

New City "Best of Chicago" issue
New City, 30 September 1993
Front page

Ware acknowledges the comic book's
place in American culture by having the
news-stand below the elevated train tracks
sell a copy of *Eightball*, by Ware's friend and
cartooning peer Daniel Clowes, alongside
XXX, *Hole Story* and *Love Den*. At lower right
a copy of *Jimmy Corrigan* lies in the gutter.

Blab! magazine
Blab! No. 8, summer 1995
Front cover
Kitchen Sink Press, Northampton
Massachusetts

This "silent", single-panel cartoon actually illustrates a babble of shouts and gossip following a chain of adultery, scandal and assassination. Start at the Super-Man, hovering in the centre, and follow the exclamation marks clockwise as a newspaper reporter would follow the money (which is quietly changing hands in a louvered room at lower left and lower right). Although Daddy Warbucks paid the Super-Man to bump off Nancy's now ex-boyfriend, Sluggo, he is thoughtful enough to console her with one of his lollipops – or "suckers", as Warbucks is doubtless on the verge of sweet-talking Nancy into replacing the disgraced Little Orphan Annie as his latest corporate spokesgirl.

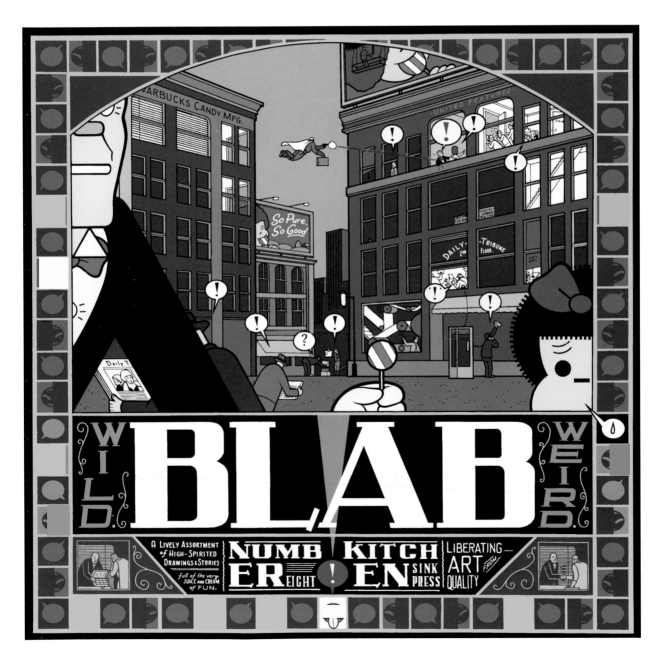

*Andrew Bird's Bowl of Fire
and the Et Cetera String Band*
Poster
Chicago, 1998

Ware designed and illustrated this
poster to promote two groups of musicians
who play the string-based dance music
of the late 19th and early 20th century.
It is doubtful that this pig-like Cheshire
of a sun enticed any tattooed rockers
to cakewalk, because most of these
silkscreens were stolen as soon as they
were posted.

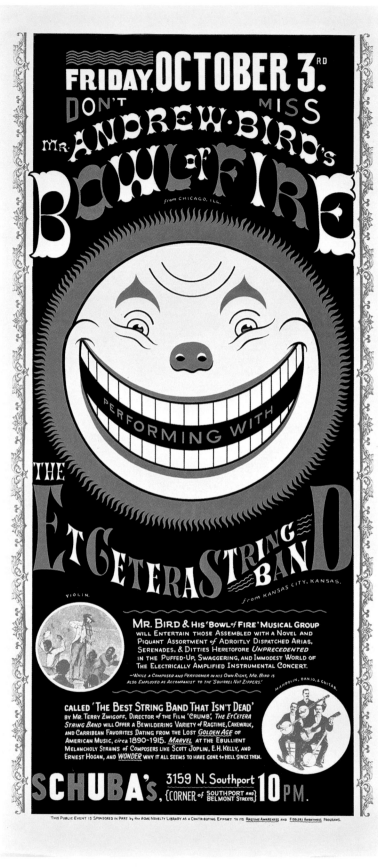

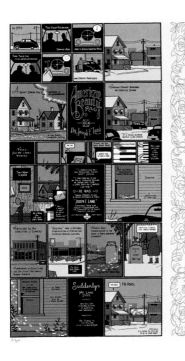

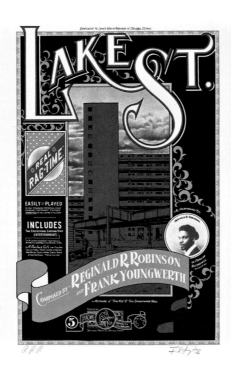

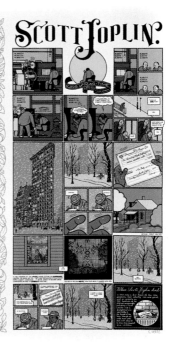

Sheet music folio for the song
"Lake Street" by Reginald R. Robinson
and Frank Youngwerth
Oog & Blik, Amsterdam, 1999

In the early 1990s Ware was studying in
the Chicago public library when he heard
ragtime music being played somewhere
in the building. Amazed, he followed the
song through the hallways to its source
in the library's basement, where a
young man named Reginald Robinson
was playing one of the library's rental
pianos. Almost immediately the two
became the best of friends. This triptych
depicts the composer's boyhood home,
flanked by a pair of strips about two
of Ware's and Robinson's favourite
composers. The verso side features the
song itself, laboriously and exquisitely
hand-noted by Mr. Robinson.

Life drawing
1993

For Ware, cartooning is composing visually
abbreviated symbols in order to tell a
story; drawing is his attempt to see the
world as it actually is, without resorting
to iconography, visual shorthand or tricks.
This drawing, which Ware did for his
beloved late drawing teacher, Richard
Keane, shows that the cartoonist is also
a dextrous and sensitive fine artist.

44

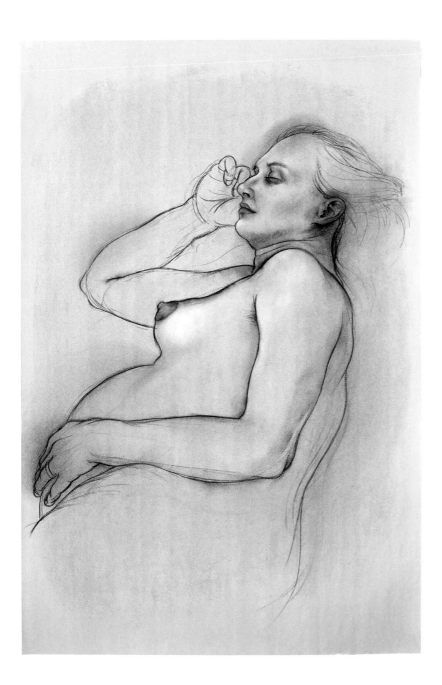

Untitled painting
1991

This painting is Ware's only remaining
piece from a large assemblage of
interrelated paintings, the rest of which
he had to sell when he was younger and
poorer. Ware grants the crippled robot
an almost noble bearing in the instant
it stumbles before falling.

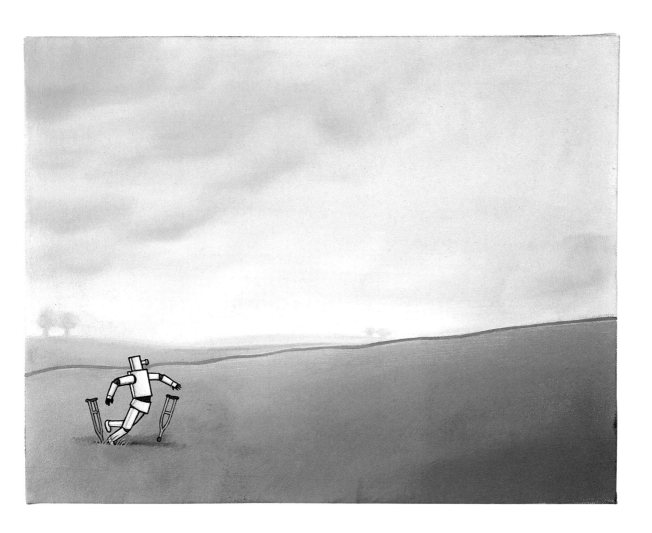

46 Sketchbook pages
Previously unpublished, 2001

Ware credits his 1987 discovery of the
published sketchbooks of Robert Crumb
with inspiring his passion for drawing,
as well as saving him from the fashionable
theories promulgated by The School of
the Art Institute of Chicago. "The books
practically exuded life to me, unlike most
of the 'art' I was being introduced to in
school," he writes in the introduction to
his *Date Book*. "Simply knowing that Robert
Crumb was alive and filling up sketchbooks
with incredible drawings I think rescued
my otherwise too-easily influenced mind
from being sucked into a world of theory-
based, message-laden nonsense."

GIRL with
INCREDIBLE HAIR at
JOHN PORCELLINO SIGNING,
1/18. GOOD LORD, SHE WAS
INCREDIBLE... HE SAID HER
NAME WAS 'LISA'...

HOLLYWOOD RD. HONG KONG. 1/14.

84

VIEW OUT SHENZHEN
HOTEL LOBBY, 1/11. Rainy day.

48 *Quimbies the Mouse*
Kinetic sculpture
48×27·6×38cm (18$^7_8$×10$^7_8$×15in)
1993

These fully articulated Siamese mice
come to life when the crank is turned.
The brass plate affixed to the base reads,
"The eyes which once regarded me with
affection were now openly indifferent,
like the way one might glance at passers-by
on the street." "It's weird," says Ware.
"The Quimbies were originally about my
grandmother dying, and Sparky the cat
head was about this horrible break-up
I was going through with my girlfriend,
but for some reason I reversed them when
I made these toys."

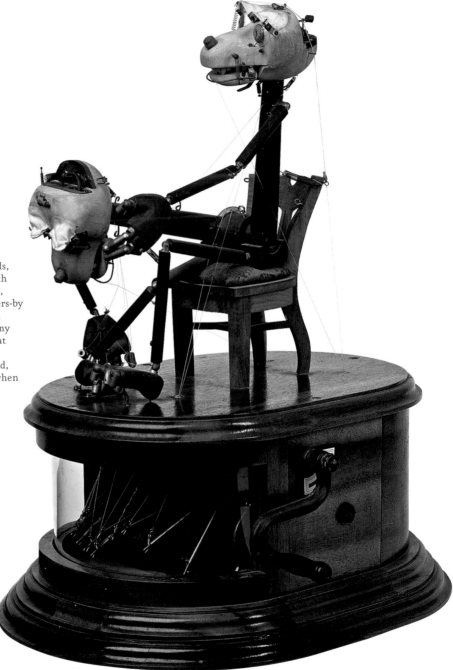

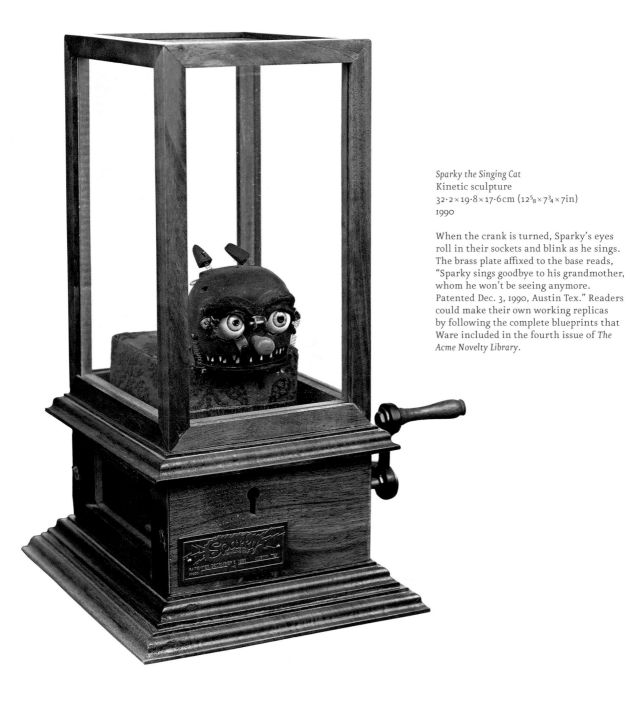

Sparky the Singing Cat
Kinetic sculpture
32·2 × 19·8 × 17·6 cm (12⅝ × 7¾ × 7 in)
1990

When the crank is turned, Sparky's eyes
roll in their sockets and blink as he sings.
The brass plate affixed to the base reads,
"Sparky sings goodbye to his grandmother,
whom he won't be seeing anymore.
Patented Dec. 3, 1990, Austin Tex." Readers
could make their own working replicas
by following the complete blueprints that
Ware included in the fourth issue of *The
Acme Novelty Library*.

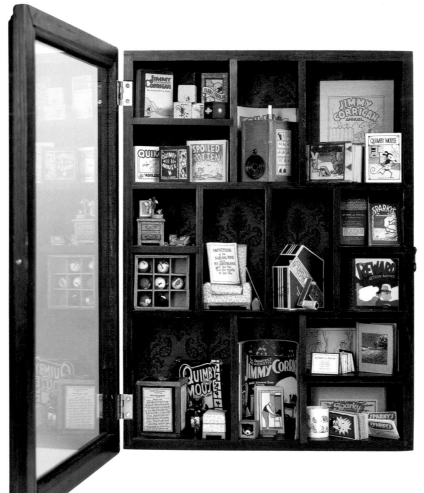

Curio cabinet
41·5 × 30 × 8cm (16$^3_8$ × 11$^7_8$ × 3$^1_8$ in)
1988–2003

Inspired by the work of the American artist Joseph Cornell, whom he reveres, Ware fashioned this panelled cabinet to hold his smallest curios and comic books, many of which are no larger than a thumbnail.

Acme Book Dispenser
54·6 × 36·5 × 25 cm (21$^1_2$ × 14$^3_8$ × 9$^7_8$ in)
1990
[OPPOSITE]

Dropping any house key into the slot in this contraption produces a miniature 60-page comic book containing the very first version of the Jimmy Corrigan "island story", unavailable elsewhere. So many people failed to read the instructions regarding the house key that in 1993 a financially desperate Ware was able to disassemble the cabinet and extract over ten dollars in mistakenly deposited change, which he immediately used to purchase eggs, milk and tortillas.

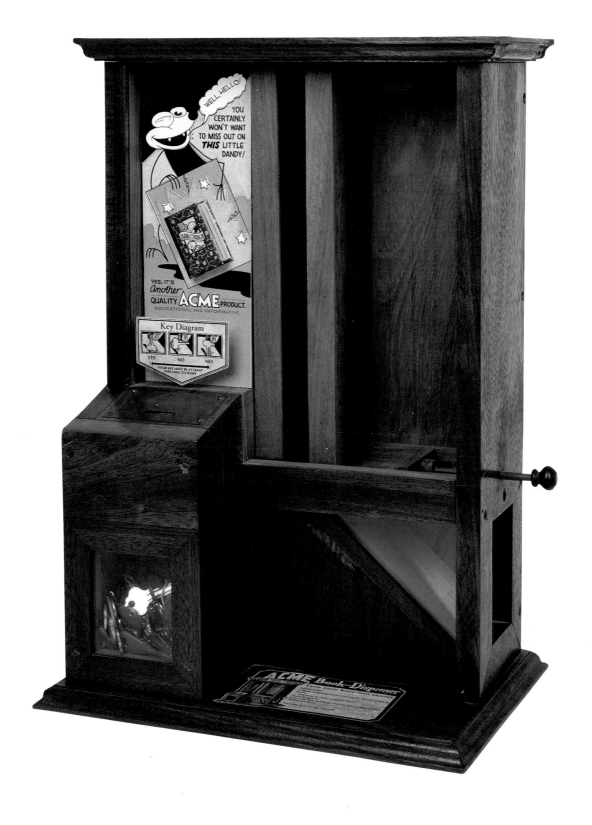

52 Potato Man's House
97·7 × 60·6 × 30·5 cm (38$\frac{1}{2}$ × 23$\frac{7}{8}$ × 12in)
1989

The panelled storeys of this home reflect
the panelled stories of Ware's comics, and
vice versa. Ware built this replica of the
Potato Man's home from the third issue
of *The Acme Novelty Library* and animated
an 8-mm film which he projected against
the bedroom wall.

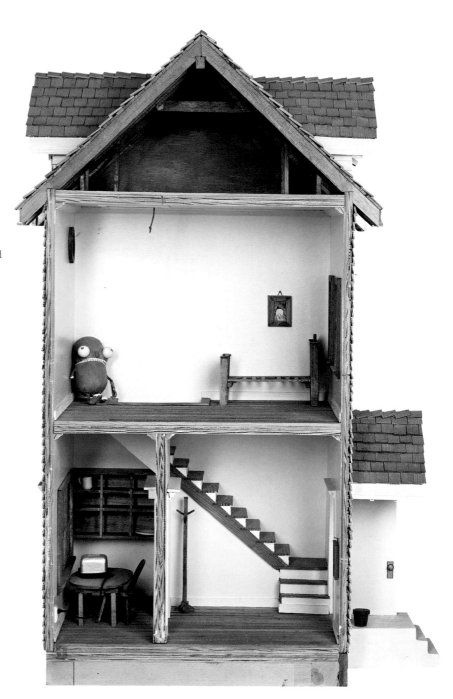

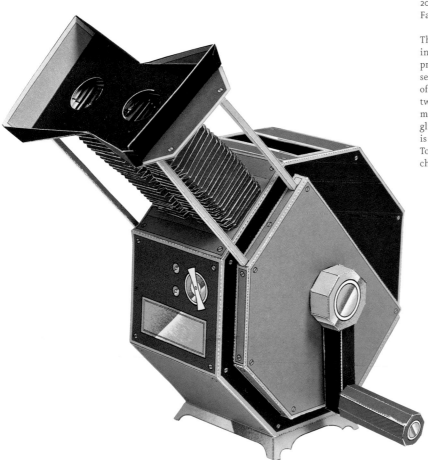

Professional Futuristic 3-D Picture Viewer
Included in *The Acme Novelty Library,*
number 15
20·4×10·5×19cm (8×4$\frac{1}{8}$×7$\frac{1}{2}$in)
Fantagraphics Books, Seattle, 2001

This build-it-yourself gizmo, which does
in fact work, operates on the same
principle as a stereo camera. It also
serves as an elaborate jab at the passivity
of modern entertainment: after spending
two or three full days cutting out the
miniature paper parts and painstakingly
gluing them all together, the only reward
is to see the frump from Ware's "Tales of
Tomorrow" series repeatedly change the
channel on his television.

The Acme Novelty Library, number 1
Front cover
Fantagraphics Books, Seattle, 1993

The Hollywood sci-fi and radio programme clichés make Jimmy's workaday life, which Ware lays bare inside the book, seem by contrast even more quotidian. "This is probably the only one of my covers that doesn't have a swipe in it," Ware says.

"By 'swipe' I mean a visual inspiration or starting point. I always try to create a cover that is a little disconcerting, but still warm enough to invite the reader."

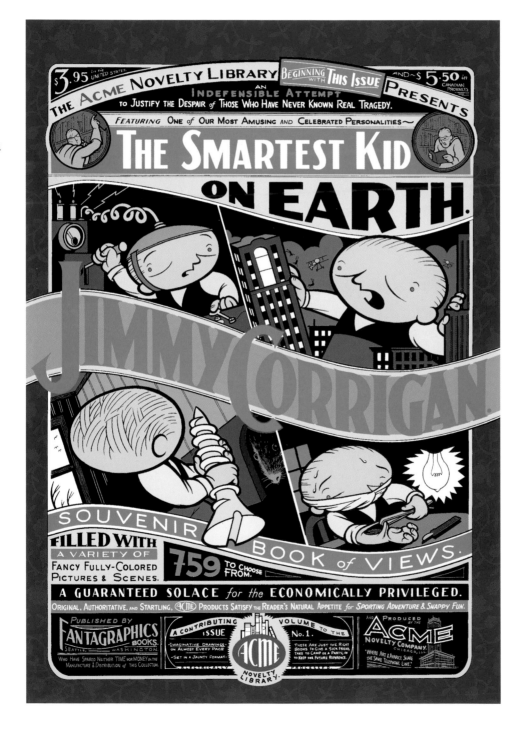

The Acme Novelty Library, number 5
Front cover
Fantagraphics Books, Seattle, 1995

America as Eden both before and after
The Fall. The ominous, sanguinary red
of the landscape hints at the bloodshed
that transformed Columbia into Chicago.
The vines wrought like ironwork around
the central window are more vivid
than the faded landscape, making the
imitation of nature seem more real than
nature itself.

The Acme Novelty Library, number 6
Front cover
Fantagraphics Books, Seattle, 1995

Like many of Ware's earlier frontispieces
and rubrics, this cover design is based –
"very vaguely," says Ware – on a Valmor
beauty products label (see page 19).

The Acme Novelty Library, number 8
Front cover
Fantagraphics Books, Seattle, 1996

"Of all my covers this one is the most
completely and blatantly swiped," says
Ware. "Of course, it's also my favorite.
Have you ever seen that book, *The Art
of the Cigar Label*? There's one called
'Columbia', where she's anchored on
the shore with all these kids crowded
around her. All I did was replace her
with a big fat horny Super-Man." And
here this writer thought that Ware
was commenting on colonialism in the
Americas. "Well yeah," Ware admits,
"I was trying for that."

The Acme Novelty Library, number 9
Front cover
Fantagraphics Books, Seattle, 1997

"I took a fruit label from an old box of
lemons, took it apart in my brain, and
reassembled it here," says Ware. Hence
his motto for this issue: "The comic book
that sours after only 8 issues." Groan.
"I tried to use peaches," says Ware,
"because peaches are actually in the story,
but their color just didn't work."

Johnson Smith & Co. Mammoth New Catalog of 9000 Novelties
Front cover
Johnson Smith & Co., Detroit, Michigan, 1941

The Acme Novelty Library, number 10
Front cover
Fantagraphics Books, Seattle, 1998

Ware swiped most of this cover from the old Johnson Smith & Co. catalogues [below left]. Johnson Smith & Co. were the purveyors of nugatory and usually fraudulent "novelties" – x-ray glasses, exploding cigarettes, Sea Monkeys and the like – which they advertised in almost every American comic book of the 1950s, 60s and 70s. Ware spoofed these ads with his own fake ads in this and other issues of *The Acme Novelty Library*.

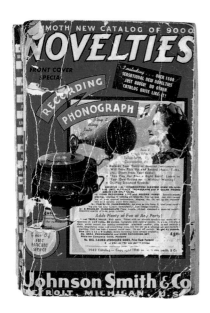

The Acme Novelty Library, number 11
Front cover
Fantagraphics Books, Seattle, 1998

This cover was inspired by the Japanese cartoonist Suihô Tagawa, right down to the pidgin-like grammar of the text, which reads as though it were translated from Japanese by a machine. Ware told Todd Hignite of *Comic Art* magazine that Tagawa, along with Frank King and George Herriman, is his favourite cartoonist who is no longer alive. Part of the reason

comics are so popular in Japan is because the pictogrammic nature of their language predisposes them to making the conceptual leap from seeing to reading. "As near as I can tell," Ware told Hignite, "the Japanese understanding of art is almost a sort of simultaneous reading and seeing, whereas ours is purely seeing – a very Western idea."[17]

The Acme Novelty Library, number 12
Front cover
Fantagraphics Books, Seattle, 1999

With the possible exception of *Acme*
number 8, this is ironically the first
cover in which Ware prominently
and unabashedly displays the actual
title of his book, *Acme*. He also displays
his jocular despair regarding the
fortunes of the comic-book business:
the logo of his publisher, Fantagraphics,
is a sinking ship.

The Acme Novelty Library, number 13
Front cover
Fantagraphics Books, Seattle, 1999

"This one is sort of based on an 1880s
reading primer," says Ware. The space
reserved for the owner's name makes
a handy space for Ware to sign the book
at his numerous and well-attended
bookstore signings.

The Acme Novelty Library, number 14
Front cover
Fantagraphics Books, Seattle, 2000

Obviously, Ware took his idea for this
design from a Pearl fruit label. The
schooner and Latin elements refer
to the slave trade that brought Amy
Corrigan's ancestors to the United States.

64 *The Acme Novelty Library*, number 15
Front cover
Fantagraphics Books, Seattle, 2001

The Aztec calendar stone of Ware's
cosmology. Ware halves this composition
into day and night, happy and sad, God
and Man. He quarters it into the four
seasons and assigns to each a point on
the spectrum of his four main characters,
each of whom he associates with certain
animals, activities and professions.
Ultimately, he links the sad sack Corrigan
with the fine arts and the happy-go-lucky
Super-Man with the venal arts. When
Ware was forced by the rules of book
distribution to place a Universal Product
Code (UPC) somewhere on his cover, he
superimposed a circular code on the yellow
circle at centre left, at the intersection
of the Tomorrow quadrant and the Super-
man quadrant – that is, at the intersection
of technology and business – thereby
integrating the UPC into his composition.

65

Jimmy Corrigan L-display stand
Pantheon, New York, 2000

In this point-of-purchase display stand
Ware manages to imbue hucksterism with
humour and a childlike dignity. Every
element parallels the book's dust jacket,
from the diagonal typography to the
compositional bars of colour that flow
into each other.

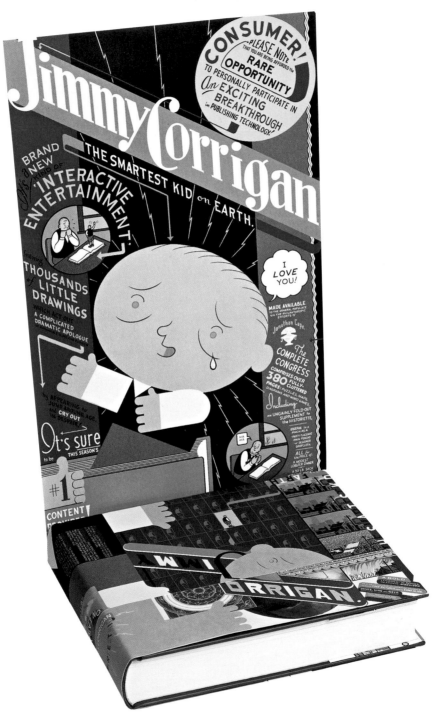

Jimmy Corrigan Official Vital Animus
PressPop Gallery, Tokyo, 2002
Sculpted by Kei Minotani
[BELOW LEFT]

Jimmy Corrigan, The Smartest Kid on Earth,
Official paperbound apologue
Pantheon, New York, 2002
[BELOW RIGHT]

The fine print on the box warns the user
of the action figure not to "interpret" it,
but it is worth noting that Ware did more
than recycle his own design. He took the
bilateral split from the book jacket and
expanded it to include a comic strip about
Jimmy's workaday life, in yellow. In
the blue half of the box he drew a strip
about Jimmy's night life: sex, Super-Man,
riches and weddings. Jimmy is dreaming,
of course.

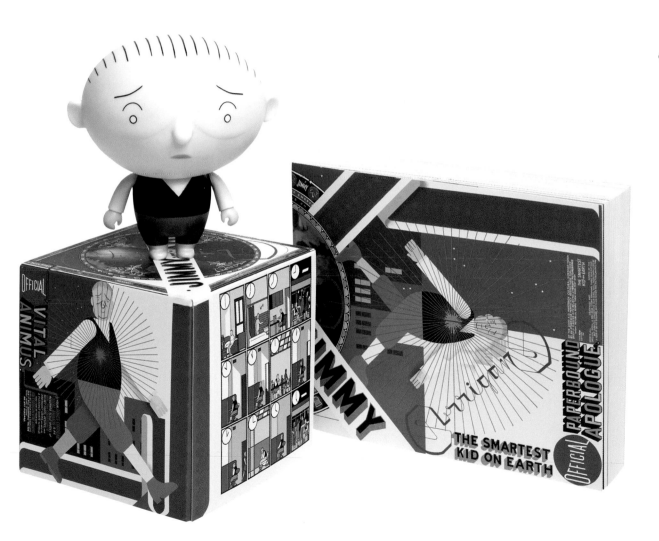

68

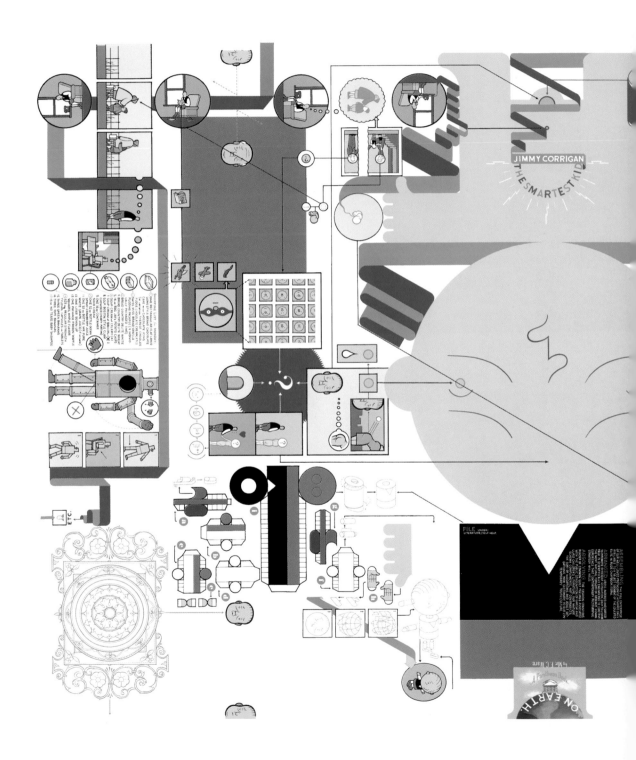

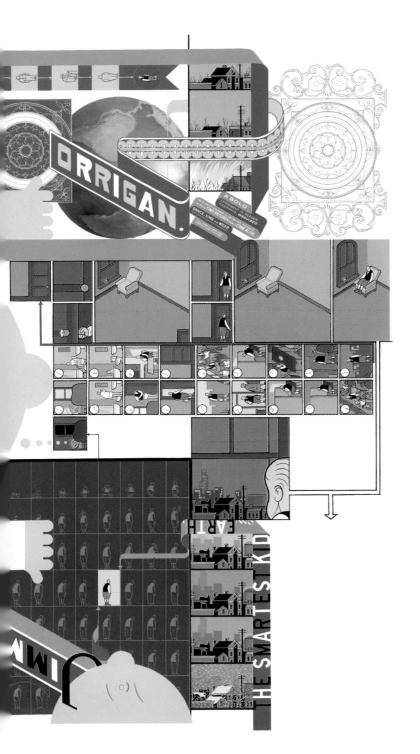

Jimmy Corrigan, *The Smartest Kid on Earth*
Hardcover dust jacket
Pantheon, New York, 2000

The dull-coloured right half of this
ideogrammic dust jacket shows the reality
of Jimmy's existence. He awakes and takes
the train to work and home again as day
turns to night, spring to winter, and he
comes one day closer to his death. But
before Jimmy wakes, he dreams, and the
pink thought balloons of this dream link
his humdrum life to the brighter fantasy
life at left. In this half a woman's bum
catches his eye, leading to a tear, memories
of his mother (!) and the central questions
of his life, namely, "Will I ever find
someone to love?" and "Who is my father?"
These sexual and biological questions lead
as black arrows to Jimmy's own sex organ,
which, when the jacket is folded around
the book, is discreetly covered by the
Pantheon Books logo. Folding also causes
Jimmy's half-face, bottom left, to meld in
the middle with his father's face, top left.

Jimmy Corrigan (continued)

When Jimmy and his father first meet
in a bar, Ware abandons the omniscient
visual narration and draws instead
Jimmy's subjective state of mind. The bar
room becomes his parents' bedroom, where
he was conceived, and snippets of the
pair's real dialogue slip invisibly in and
out of the imaginary murder Jimmy
daydreams of committing. By substituting
first-person for third-person in the visual
narration, Ware literally builds Jimmy's
emotions into the book.

70

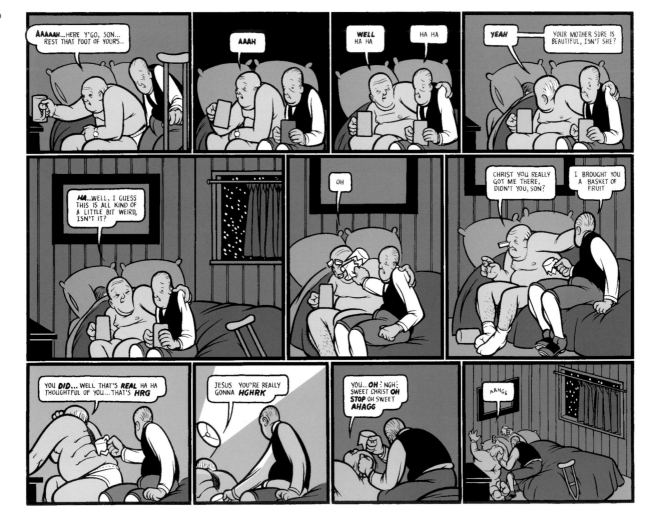

When Jimmy tries to tell his father how he feels about being abandoned by him, Ware shows Jimmy's tension by drawing the panel in red and green, which vibrate against each other, and by suddenly reducing Jimmy to a child.

He also prints most of Jimmy's utterance outside the panel, in the spot traditionally reserved in comics for narration. This switch has a paradoxical, two-fold effect. First, it gives Jimmy's halting assertion an authority it would not otherwise have: for a moment Jimmy himself is speaking with the timeless, omniscient authority of a narrator. At the same time, Jimmy's disembodied voice also seems less substantial, like the peculiar feeling we have when we try to listen to our own voice echoing inside our head.

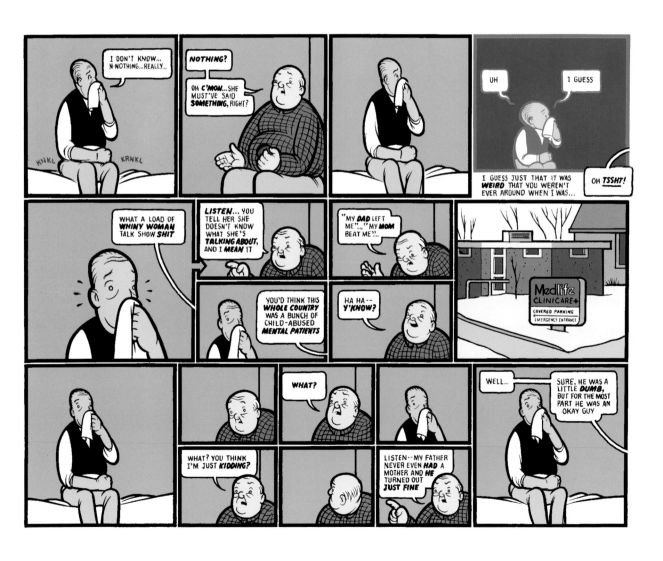

Jimmy Corrigan (continued)

If he is working in a naturalistic mode, the good cartoonist needs to be a good actor. This page is the clearest example of how Ware writes with body language. In essence, you can read this panel without reading what Jim Corrigan is saying. His coughing, scratching, chin-stroking and pants-pinching are the mannerisms of the amateur bullshit artist.

As the doctor says to Jim on the next page, "There you go – telling lies again." Ware also builds these lies into the story using plain text. If one follows the cadence of

Jim's speech, the boldened words mark the overly metrical, nearly-rehearsed rhythm of his bluster. Ware reinforces this effect by not once including the listener, Jimmy, on the page, showing that Jim's performance is oddly self-contained in the way that liars' performances necessarily are.

72

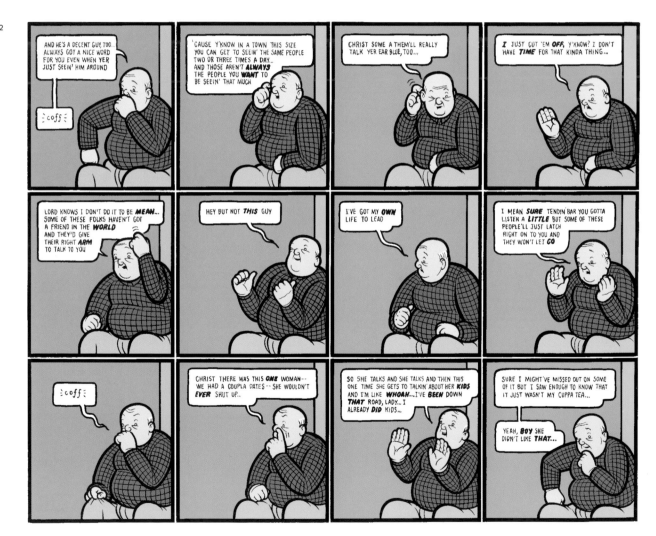

This page is one drawing subdivided into twelve panels, each representing a different point in space or time – which are the same thing, basically, in comics. As James seeks the red-haired girl his movements form a question mark that curls around the fifth and sixth panels, which "exist" 50 years ago in time. This is more startling because the Italian boy has time-travelled back along with the narrator. Ware eases the reader out of this wormhole into more conventional comics storytelling by using a transitional panel, which shows the time when the Corrigan home was only a frame, before he returns to the story's present.

In prose a writer can describe one setting in infinite ways, but in naturalistic comics a writer has to ensure that he draws his setting exactly the same, time after time, from many perspectives. Ware built this model to help him keep his facts straight.

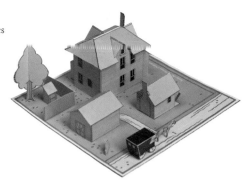

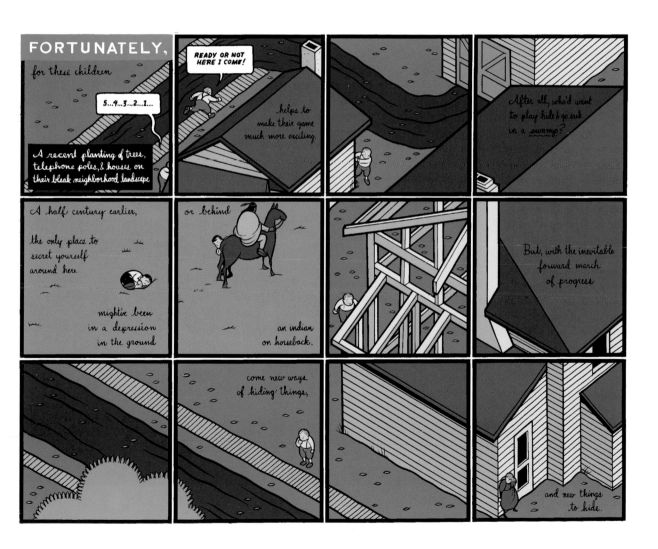

Ware composed the panels of this spread in near-perfect bilateral symmetry in order to reflect the architecture it depicts, that of the 1893 World's Columbian Exposition. Ware has clothed James Corrigan in a white nightshirt to visually reinforce James' feeling that he is dreaming, and to point out that James' first-person memories of the event are somewhat unreliable.

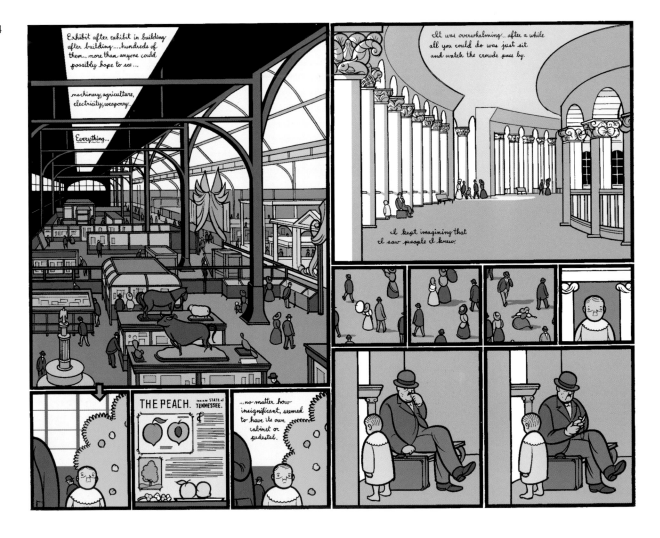

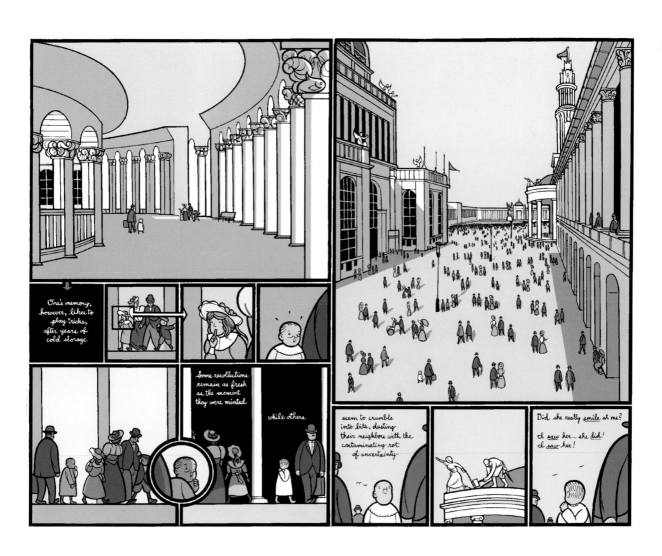

One's memory, however, likes to play tricks, after years of cold storage.

Some recollections remain as fresh as the moment they were minted

while others

seem to crumble into bits, dusting their neighbors with the contaminating rot of uncertainty

Did she really smile at me?

I *saw* her... she *did!* I *saw* her!

The composition of this page begins
and ends with Jimmy's reality while
the other two corners are Hollywood
sunsets. The four corners anchor a cross
of fantasies which reveal that Jimmy
is falling in love with his (gulp) sister.

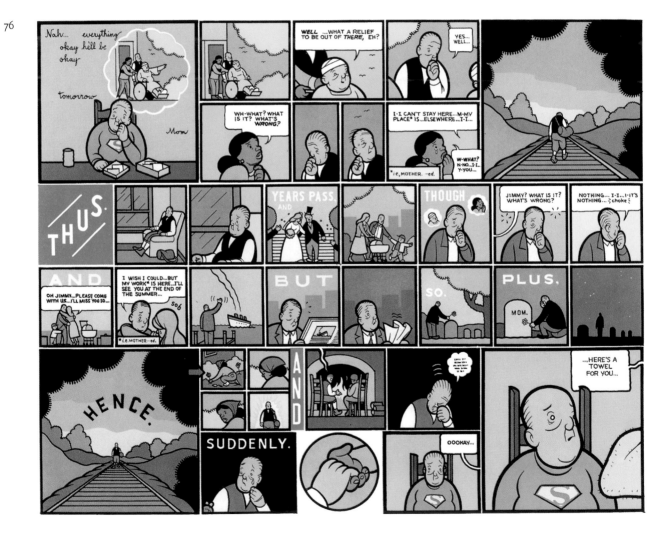

Jimmy tries to leave the room before
his grandfather can say another word.
Ware indicates Jimmy's urgency by
cropping closely on Jimmy's bum foot,
step by step, against an alternating light
and dark green background, which
creates the same rhythm as his hobble.

By placing the open circle panel of Jimmy's
face, centre, next to the close-up of the
circular doorknob, Ware visually links
the two and shows how intently Jimmy
is focused on escaping the room. Ware
shrinks the concluding cluster of panels
to show the brief, claustrophobic nature
of this anticlimax, as he touches the 1890s
half of his novel to its 1980s counterpart.

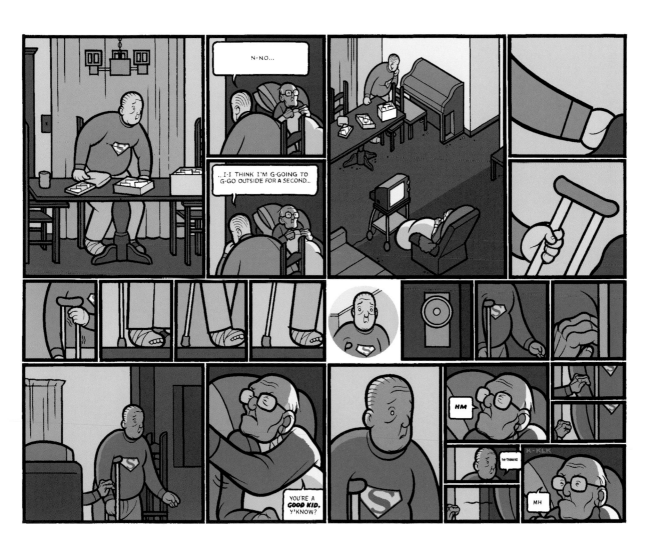

Ware has said that he tried to structure
his Jimmy Corrigan story symphonically.
This wordless, or "silent" passage is then
the climax of his novel's fourth movement.
It comes immediately after Jimmy's
father dies and is consonant with the
wordless passage that immediately
followed Jimmy's first meeting with his
father. The way that Ware shows the events
linking Jimmy and Amy by blood – using
neither words nor action – is something
that can be done only in comics. One is
tempted to call it "musical".

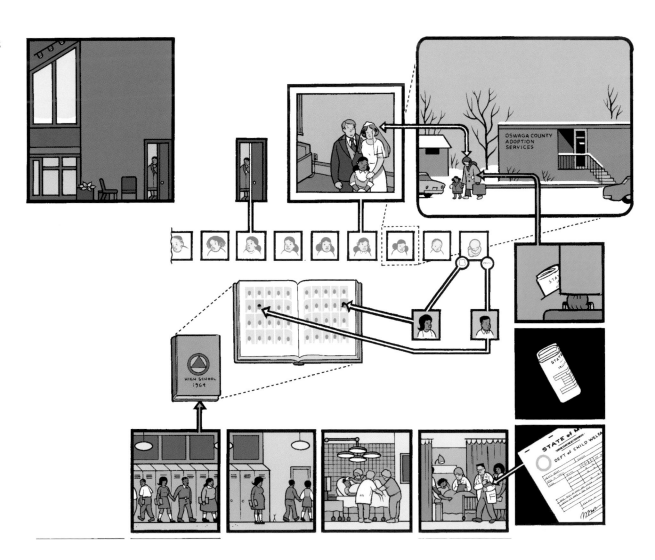

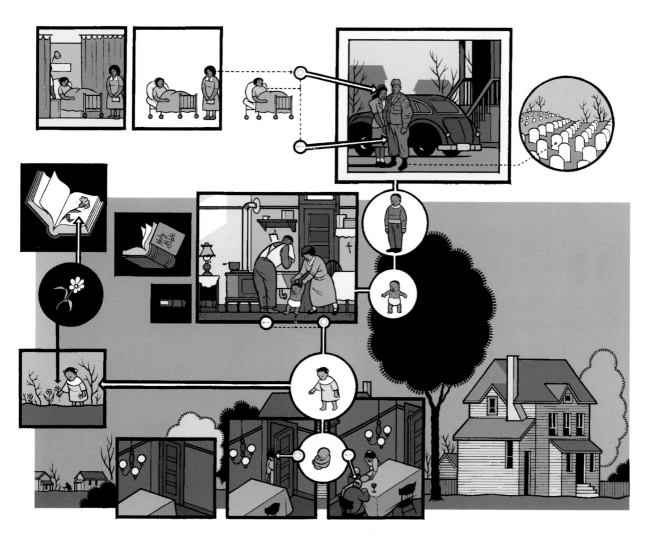

The Acme Novelty Library Freestanding
Cardboard Display
Fantagraphics Books, Seattle, 1998

Cyan and dandelion yellow give the
illusion of cheer to this towering
slaughterhouse, wherein mice blindfold
other mice, chain them and shoot them.
They nail the corpses to canvas panels
along with captured speech balloons filled
with the dictation of the overseer/muse
barking into his long red microphone.
These panels are then ordered sequentially
onto pages, bound into books, and
railroaded to comics retailers, who one
hopes will store them in the "adults only"
section of their shops. Ware swiped the
phrase "The Present Day Fad" from the
sheet music to Max Hoffman's 1897 song,
"Rag Medley".

80

Fine Art Display Collectible Item
Cast resin statuette
21·5×10×6·5cm (8$\frac{1}{2}$×4×2$\frac{1}{2}$in)
Sculpted by Alex Ross
Chicago Comics Ltd., Chicago, 2002

This cheap plastic toy was commissioned
by Eric Kirsammer to commemorate
the decade-long survival of his shop,
Chicago Comics. Ware planned the dummy
on paper and Alex Ross, the superhero
artist, modelled the clay for the mould.
The statuettes are available in either
red, yellow, white or blue, although
Ware prefers what he calls the "gravitas"
of the white.

The Raeburn Algorithmatic
Painted wooden toy
21×16×4cm (8$\frac{1}{4}$×6$\frac{1}{4}$×1$\frac{1}{2}$in)
2002

Ware made this toy as a gift for the
author's wife. For years Ware and his
fellow cartoonist Ivan Brunetti have
used their term, "the Raeburn algorithm",
to describe the author's habit of
"improving" an otherwise humdrum
story or previously-agreed-upon chain
of events. The back of the packaging reads,
"GUARANTEED: To make any story,
recollection, or explanation more colorful,
concise, and utterly flabbergasting.

GREAT FOR: cocktail parties, fabricating
excuses to girlfriends, writing about
popular children's art forms that were
completely dismissed in the public
consciousness over a half century ago."

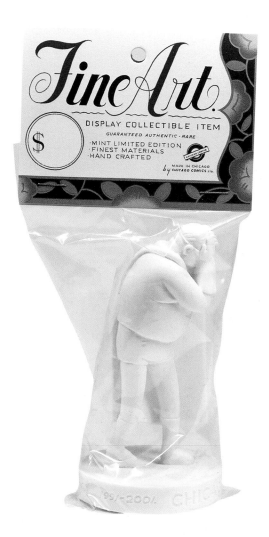

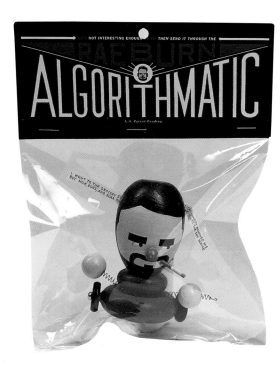

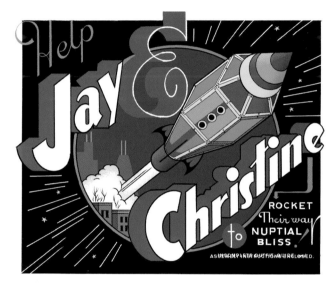

Wedding invitation for
James & Christine Doering
2 November 2002

Evidence of the lengths to which Ware
goes when it comes to helping his friends.
The reverse of this offset-printed
wedding invitation is a dead-on parody
of an old-time revival poster, set in
woodcut typefaces advertising "a
Celebratory Banquet of Bounteous
Splendor & Extensive Aliment, all deeply
toned by a Degree of Extemporaneous
INSOBRIETY heretofore foreign to the
Kalamazoo region".

TAIL SECTION.

NOSE CONE.

MAP.

SLEEPING BAGS.

SERVANT TAX.

FISHING RODS, SWORD.

MEAT.

COFFEE.

TENT.

WORM DRIVE CIRCULAR SAW.

RIFLE.

BEVERAGE.

CONCRETE.

BEVERAGES.

LIVING QUARTERS.

FLOWERS.

PAPAL APPROVAL.

CAMERAS.

SKILLET.

RINGS.

NOVEMBER 2 2002 4:13

JAY. CHRISTINE.

CHICAGO.

JAY.

CHRISTINE.

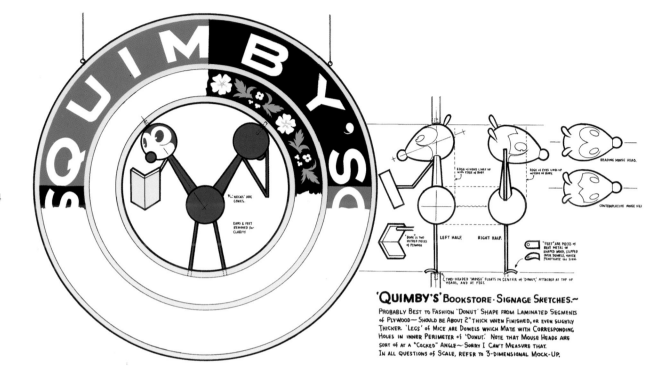

'QUIMBY'S' BOOKSTORE · SIGNAGE SKETCHES.~

PROBABLY BEST TO FASHION 'DONUT' SHAPE FROM LAMINATED SEGMENTS
OF PLYWOOD — SHOULD BE ABOUT 2" THICK WHEN FINISHED, OR EVEN SLIGHTLY
THICKER. 'LEGS' OF MICE ARE DOWELS WHICH MATE WITH CORRESPONDING
HOLES IN INNER PERIMETER OF 'DONUT.' NOTE THAT MOUSE HEADS ARE
SORT OF AT A "COCKED" ANGLE ~ SORRY I CAN'T MEASURE THAT.
IN ALL QUESTIONS OF SCALE, REFER TO 3-DIMENSIONAL MOCK-UP.

Sketch for hanging sign outside
Quimby's Bookstore, Chicago, 1996

Since 1991, Quimby's Bookstore has been
the hub of Chicago's literary and artistic
underground. In appreciation Ware
designed their advertising signage and
business cards, which read, "Specialists
in the Importation, Distribution, & Sale
of Unusual Publications, Aberrant
Periodicals, Saucy Comic Booklets,
and Assorted Fancies, as well as a
comprehensive miscellany of the latest
Independent Zines that all the kids
have been talking about. GUARANTEED
to satisfy the soul beaten flat by our
mainstream culture's relentless insistence
on dumb pictures and insulting syntax."
Although Quimby's expressions are more
apparent on the business card, the
differing curvature of the eyebrows shows
that the more contemplative half of
Quimby is stunned, even saddened, by
what the other half is eagerly reading.

"The Chicago Stock Exchange"
2003, for Ira Glass' story about
Tim Samuelson in *This American Life's*
"Lost in America" tour

This is a small portion of the animated
sequences Ware designed to accompany
Ira Glass' story about Tim Samuelson of
the Chicago Historical Society and his
obsession with the now largely destroyed
work of the Chicago architect Louis
Sullivan. "Basically, Sullivan was trying
to make real the structure of life itself,"
says Ware. "He reduced organic shapes
and forms to their most basic level and
made them the building blocks of his
structures. He turned them into the
patterns of movement, and of life –
literally – that we are all unconsciously
aware of. He took these forms and patterns
and froze them in space and time, so
that we could appreciate them in a way
that's otherwise impossible. Sullivan's
contemporaries talked about him as a
humanist poet who just happened to be
an architect."

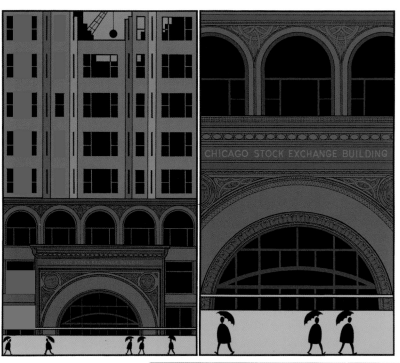

CHICAGO STOCK EXCHANGE BUILDING

CHICAGO

826 Valencia Mural
San Francisco, 2002

Dave Eggers of *McSweeney's* magazine
comissioned this mural to adorn the
writing centre he founded at 826 Valencia
in San Francisco. In each of the
composition's quadrants Ware diagrams
the ways in which our need for food,
sex and shelter drives civilization and
the development of thought, speech
and writing. This progress terminates
at lower right with the onset of television.
Meanwhile, back in the cave at lower
left, a lone mouse develops visual art
in utter isolation.

Quimby the Mouse
Back [BELOW], front [OPPOSITE]
Fantagraphics Books, Seattle, 2003

The horizontal and vertical centrelines
divide the front cover into quadrants, one
for each successive stage of Quimby and
Sparky's love affair, just as the quadrants
on the back cover depict four progressive
stages of civilization.

"Every Morning"
Quimby the Mouse
Pages 34–35
Fantagraphics Books, Seattle, 2003

As Ware remembers his grandmother, Weese, he visually reverts to childhood. Ware accentuates this motif by pulling back his authorial "camera" until the giant, climactic panel, where he has shrunk himself to optical insignificance.

In the three denouement panels Ware changes the quality of his drawing line from a wavering, handmade line to a bold, ruler-straight line, marking the end of his memory and the start of his return to reality. The bedside lamp is the same lamp around which Ware had earlier composed an entire strip, commonly known as "the lamp strip". In order to make the connection more clear, Ware put the two strips next to each other when he repackaged these old newspaper strips

90

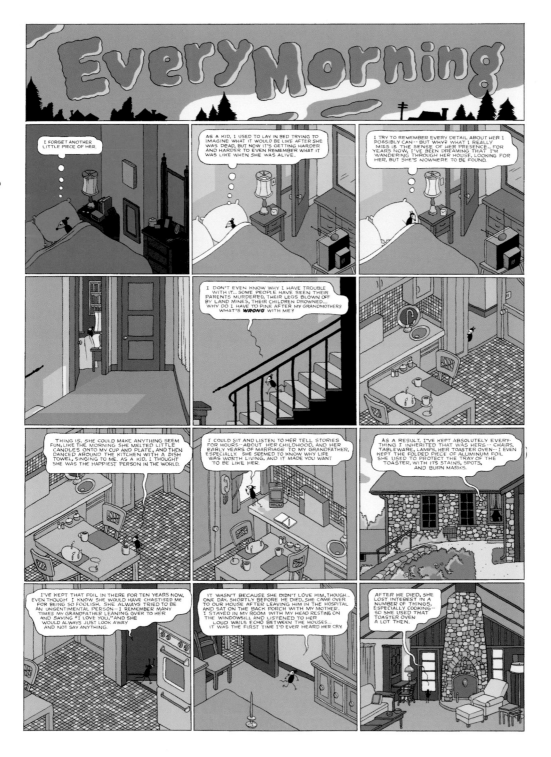

for his *Quimby the Mouse* compendium. When Ware initially drew this strip, he portrayed himself as a human adult, then a child, but he saw that the vulgar realism blocked the reader's imagination from fully entering the story, so he redrew himself as his more archetypal and more universal alter ego, Quimby.

The Acme Novelty Date Book
Back [BELOW], front [OPPOSITE]
Drawn & Quarterly, Montreal, 2003
With Oog & Blik, Amsterdam

Between 1986 and 1995 Ware filled up
approximately 1,500 pages of sketchbooks.
"I was able to find about 200 [pages] that
I guess didn't seem too terrible," he writes
in his introduction to this book of what
he calls "unbearable … awful … overly
labored nonsense". The timeline on the
front cover, designed to look like a cheap
child's wristwatch, is reflected on the
back cover by a more detailed timeline
which ends by predicting that this book's
publication will cause Ware's wife to leave
him and force him to seek employment
in the fast-food industry.

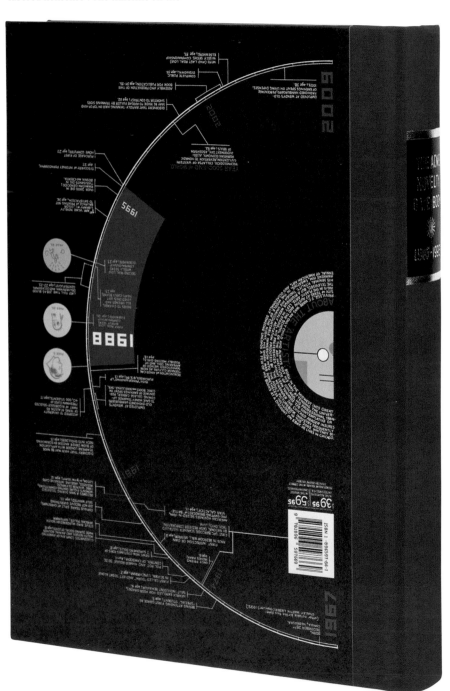

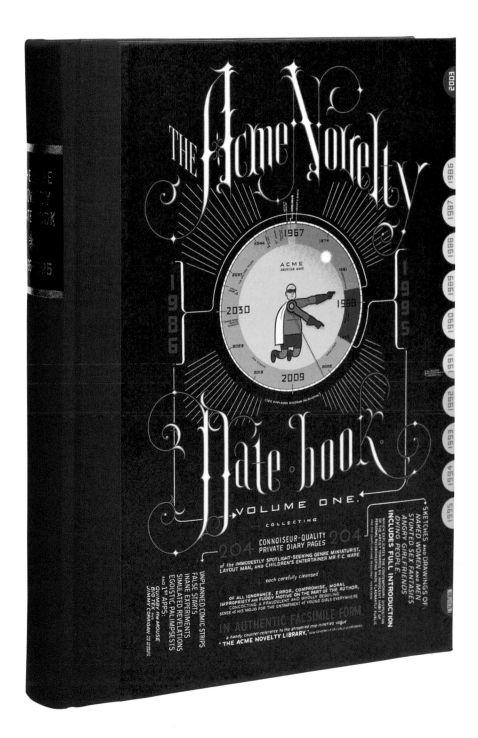

Branford, the Best Bee in the World
The Chicago *Reader*, 21 June 2002
Section 4, page 33

Branford Bee lives with his wife and
children in a hive next to the building in
Ware's *Building*. He flies in and out of the
Building strips, linking its main storyline
with his own.

94

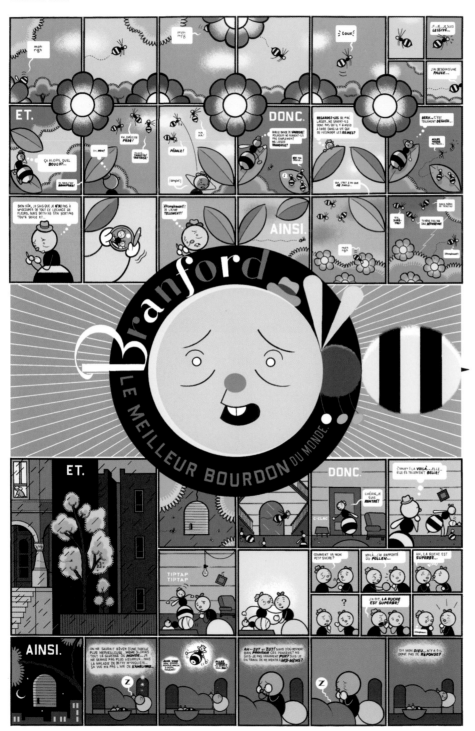

Comic supplement to the Chicago *Reader*
The Chicago *Reader*, 20 December 2002
Page 1

Ware splits each of the year's twelve panels diagonally to give his page the overall up and down rhythm of its title. This split also allows Ware to use colour and writing to show how Chalky White's life oddly parallels the life of his daughter, Brittany, balancing his cloying optimism against her corrosive narcissism. Ware ends the strip by inverting the same panel he began with, reinforcing Brittany's final complaint, "Time has stopped", as well as her father's chesnut, "Life … goes by faster and faster."

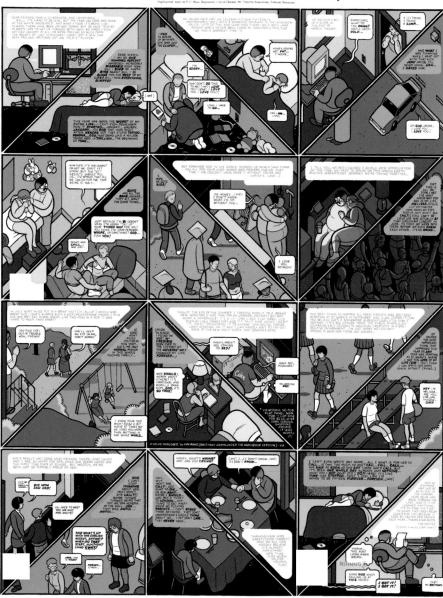

Building the strip *Building*
The Chicago *Reader*, 6 September 2002
Section 4, page 33

When Ware wants a break from working
on the longer, more straightforward
narrative of his *Rusty Brown* story, he works
on *Building*, a non-linear, interwoven story
whose warp and woof are, he says, "more
like the way I actually *think*". He agonizes
most over the writing of the strip, in
blue pencil, as shown by the number
of panels and tangents he abandons
as he struggles to compose the story.
After that his work is purely visual,
from the relatively mechanical act of
inking to the literally mechanical act
of colouring it on a computer.

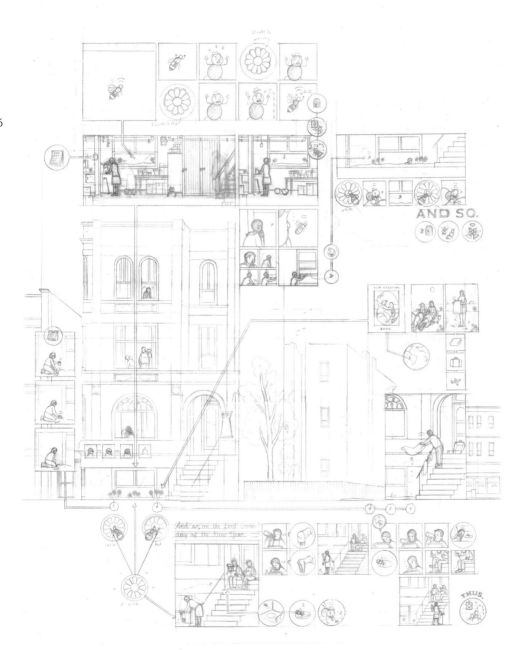

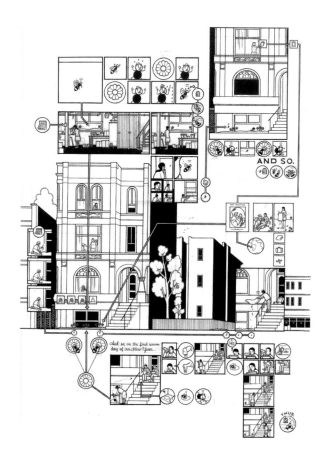
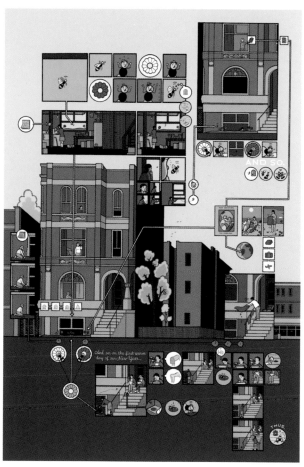

Ware takes the triptych structure of
this strip from the "Anatomy" entry of
an encyclopedia, which the protagonist
is pulling from the shelf. Ware exposes
the narrator's interior life like the acetate
overlays in the encyclopedia, uniting his
composition with a series of red circles
containing her beating heart. The strip
ends with the narrator ruminating on
the actual feeling of heartbreak and on
the precise location of her consciousness
between her eyebrows, where, she muses,
women from the East sometimes place
a red circle.

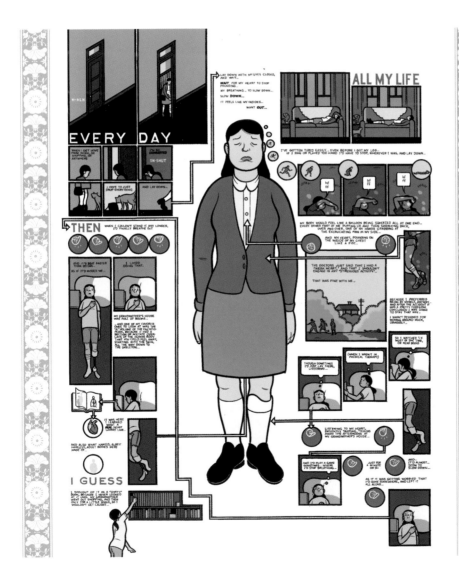

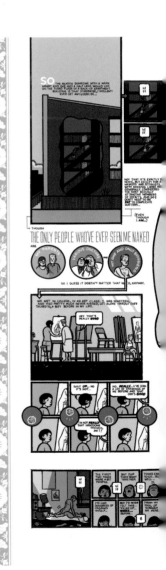

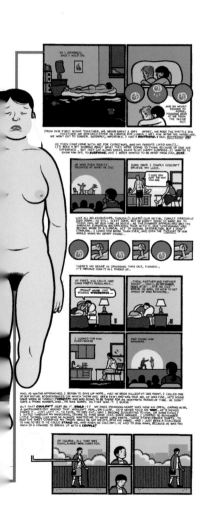

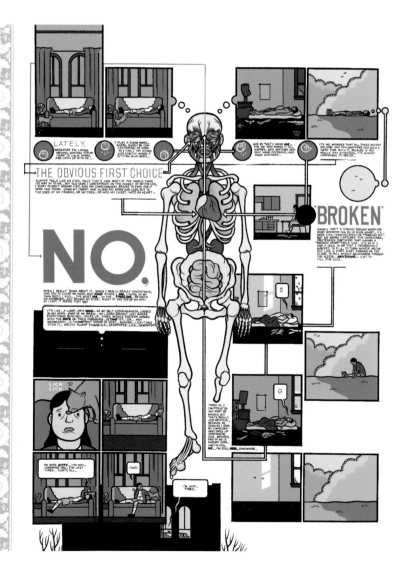

Rusty Brown
New City, 14 December 2000
Page 49
[BELOW TOP]

Rusty Brown
New City, 1 February 2001
Page 36
[BELOW BOTTOM]

Because each of his strips appears at least once in the newspaper, then in his comic book, and finally between hard covers, Ware has ample opportunity to refine his pacing and rhythm. When Ware compressed the passage at the top into the sequence at the bottom he not only fit more beats into the strip, effectively making it longer, he also heightened the drama between Rusty Brown and his teacher, Ms. Cole, by cropping more closely on Rusty and especially on Ms. Cole's eyeglasses. Ware's edits help create the same claustrophobic intimacy that Rusty himself feels as he is chastened.

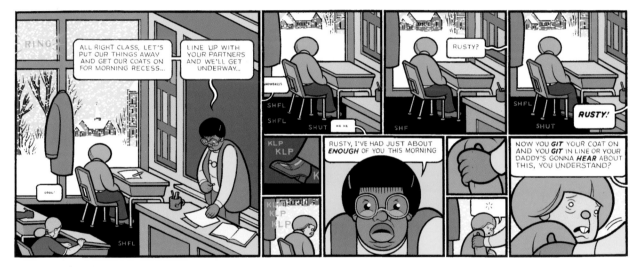

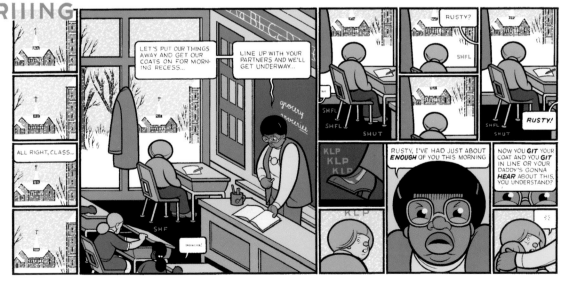

The "Chris Ware" character in *Rusty Brown* is a pretentious egghead who teaches high-school art and gets stoned with his students in the back of a Camaro. His great regret in life is apparently the recent loss of his ponytail.

Rusty Brown
The Chicago *Reader*, 18 October 2002
Section 4, page 33

This part of the *Rusty Brown* storyline takes
place during a manned mission to Mars
and includes a pair of visual tributes to the
Stanley Kubrick film, *2001: A Space Odyssey.*

102

Rusty Brown printer's dummy
2004

In order to gauge Rusty Brown's overall
composition, pacing and rhythm, Ware
pastes a photocopy of each week's strip
into this printer's dummy of his novel-
in-progress. In order to procrastinate,
he also paints each character's face onto
a set of wooden balls.

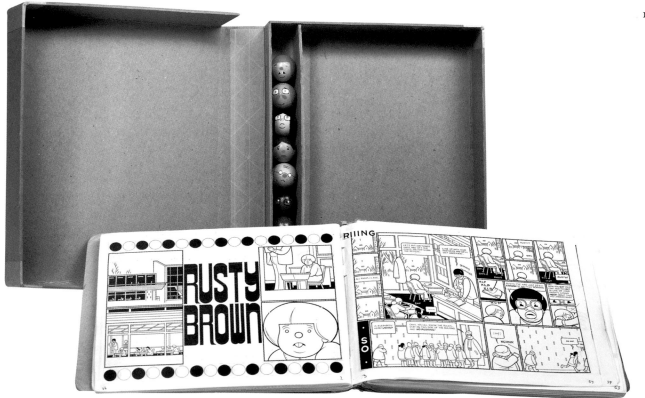

These pages from Ware's novel-in-progress
show how the book's physical structure
reflects the character's emotional
cycles of elation and disappointment.

Ware switches the visual perspective
to a bird's-eye view when he uses the
omniscient, authorial perspective that
allows the reader to hear Rusty and
Chalky's private thoughts. He uses a
similar seasonal structure on the four
lateral sides of his Rusty Brown lunch
box (pages 108–09).

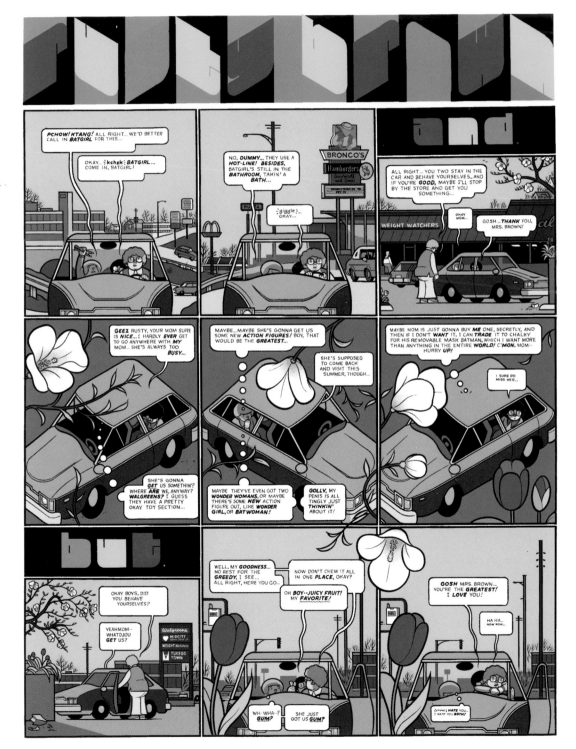

104

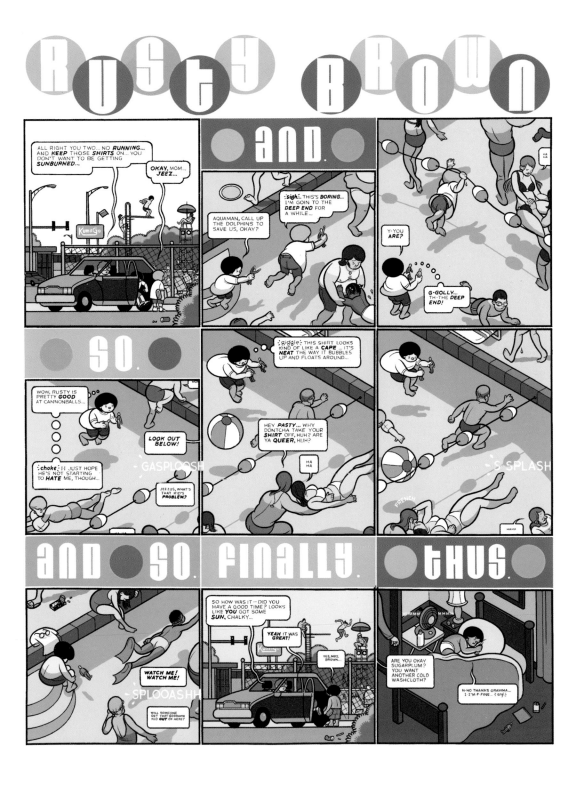

106

Rusty Brown

and.

finally.

Rusty Brown lunch box
Dark Horse Comics, Inc., Milwaukie,
Oregon, 2001

On the front of the box Ware has embossed
Rusty and his lunch to make the lonely
boy literally stand out. The rear panel
of the box shows Rusty lying awake at
night, anticipating holding his new lunch
box on the first day of school. The inside
of the box shows Rusty lying awake at
night, 30 years later, after failing to
purchase the same model lunch box for
$250 at a nostalgia shop.

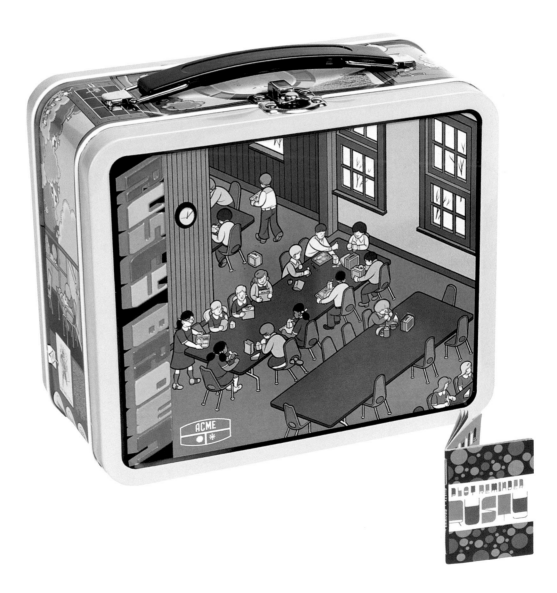

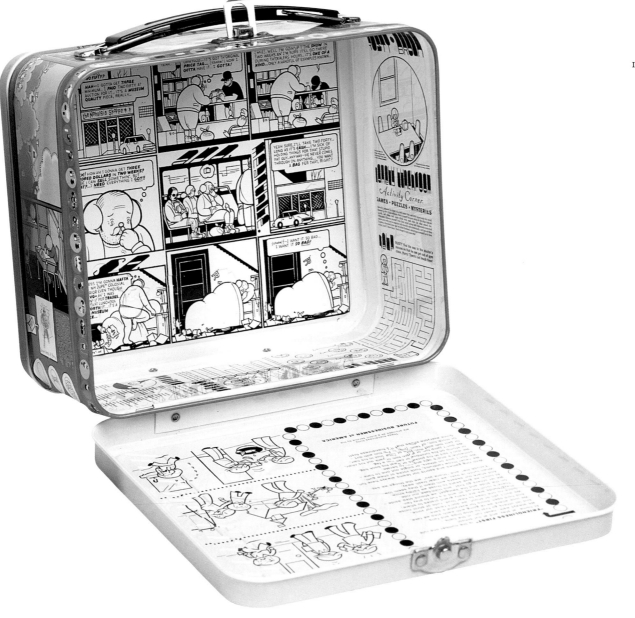

Notes

1. For a more detailed discussion of this relationship, see an essay by the distinguished amateur linguist Benjamin Lee Whorf in Benjamin Lee Whorf, *Language, Thought and Reality: Selected Writings*, ed. John B. Carroll, Cambridge, MA: The MIT Press, 1956, p. 258.

2. E. Wiese (ed., trans.), *Enter: The Comics. Rodolphe Töpffer's Essay on Physiognomy and the True Story of Monsieur Crépin*, Lincoln, Nebraska: University of Nebraska Press, 1965. I should note that although Töpffer was already making comic books by the late 1820s he did not record and codify his understanding of them to the extent I have described until the end of his life, in 1845, sixteen years after Goethe's speculation.

3. Quoted in David Kunzle, *The History of the Comic Strip: The Nineteenth Century*, Berkeley: University of California Press, 1990, p. 29.

4. Quoted in Wiese, *Enter: The Comics*, p. x, itself footnoting John Oxenford (trans.), *Conversations of Goethe with Eckermann and Soret*, London, 1875, p. 503 (entry for 4 January 1831.)

5. I snicker at the neologism first for its insecure pretension – the literary equivalent of calling a garbage man a "sanitation engineer" – and second because a "graphic novel" is in fact the very thing it is ashamed to admit: a comic book, rather than a comic pamphlet or comic magazine.

6. Telephone conversation between Chris Ware and Art Spiegelman, 2001, reported by Ware.

7. Unless marked otherwise, all quotations are from the author's conversations with Chris Ware, October 2003.

8. See Sarah Van Boven, "A Certain Comic Genius," *Newsweek*, 7 April 1998, p. 70.

9. I routinely find Art Spiegelman's holocaust memoir, *Maus*, filed in the "Humour" section of shops. Ware attempted to outwit these imbecilities with irony, instructing vendors of *The Acme Novelty Library* number 15, "Do not display in respectable bookstore anywhere near fiction, art, or literature. File *only* under: Science Fiction and Role-playing Games."

10. Peter Schjeldahl, "Do It Yourself: Biennial Follies at the Whitney," the *New Yorker*, 25 March 2002. Schjeldahl wrote: "Are these things art? The question lacks traction in a show in which 'art' is moot except as a catchall for objects and activities that aren't clearly something else or – as in the skilled but self-absorbed comic strips of Chris Ware – are too cool to ignore. (Like television advertisers, this Biennial pants after the youth market.)"

11. *The Acme Novelty Date Book*, Montreal: Drawn & Quarterly, 2003, p. 40.

12. In his essential book, *Understanding Comics*, the cartoonist and comics theorist Scott McCloud explains in greater detail comics' balance between reduction and exaggeration. He also shows how the reductive element of the comics language is not only at the root of visual, or "sign" language, but at the root of written language as well. McCloud draws a pair of glyphs and shows how scribes abstracted these pictures over time into symbols, increasingly meant to represent not the object but the sound of the word, eventually becoming unrecognizable descendants of the original icon. (*Understanding Comics: The Invisible Art*, Northampton, MA: Tundra, 1993, p. 142.)

13. See Art Spiegelman, "Comix: An Idiosyncratic Historical and Aesthetic Overview", in *Comix, Graphics, Essays & Scraps (From Maus to Now to MAUS to Now)*, Italy: Sellerio Editore-La Centrale dell'Arte, 1999, p. 74.

14. *The Acme Novelty Date Book*, p. 53.

15. Art Spiegelman, "Comix", p. 74.

16. *The Acme Novelty Date Book*, p. 190.

17. Quoted in Todd Hignite, "Chris Ware: In the Studio", *Comic Art*, no. 3, summer 2003, p.10.

Selected Bibliography

Publications by Chris Ware

Note: Almost all of Ware's strips were published in newspapers before being reprinted in other formats. They are listed here according to their first appearance.

NEWSPAPER STRIPS
Various titles, weekly and daily, *The Daily Texan*, 1986–1992.

Various titles, weekly, *New City*, 1992–2002.

Various titles, weekly, the Chicago *Reader*, 2002–present.

COMIC PAMPHLETS AND BOOKS
Floyd Farland, Citizen of the Future, Forestville, California: Eclipse books, 1987.

Jimmy Corrigan, The Smartest Kid on Earth, Magic Souvenir Book of Views, self-published, Chicago, 1992.

Lonely Comics & Stories, self-published, Chicago, 1992.

The Acme Novelty Library, number 1, Seattle: Fantagraphics Books, 1993.

The Acme Novelty Library, number 2, Seattle: Fantagraphics Books, 1994.

The Acme Novelty Library, number 3, Seattle: Fantagraphics Books, 1994.

The Acme Novelty Library, number 4, Seattle: Fantagraphics Books, 1994.

The Acme Novelty Library, number 5, Seattle: Fantagraphics Books, 1995.

The Acme Novelty Library, number 6, Seattle: Fantagraphics Books, 1995.

The Acme Novelty Library, number 7, Seattle: Fantagraphics Books, 1996.

The Acme Novelty Library, number 8, Fantagraphics Books, Seattle, 1996.

The Acme Novelty Library, number 9, Seattle: Fantagraphics Books, 1997.

The Acme Novelty Library, number 10, Seattle: Fantagraphics Books, 1998.

The Acme Novelty Library, number 11, Seattle: Fantagraphics Books, 1998.

The Acme Novelty Library, number 12, Seattle: Fantagraphics Books, 1999.

The Acme Novelty Library, number 13, Seattle: Fantagraphics Books, 1999.

The Acme Novelty Library, number 14, Fantagraphics Books, Seattle, 2000.

Jimmy Corrigan, The Smartest Kid on Earth, New York: Pantheon, 2000.

The Acme Novelty Library, number 15, Seattle: Fantagraphics Books, 2001.

Quimby the Mouse, Seattle: Fantagraphics Books, 2003.

SKETCHBOOK
The Acme Novelty Date Book, Montreal: Drawn & Quarterly and Amsterdam: Oog & Blik, 2003.

SHORT STORIES
"A Very Sad Story about a Frog and a Banjo, Not at All Appropriate for Children", *McSweeney's* no. 6, 2001, pp. 131–35.

"These New Fall Colors Don't Run", *The New Yorker*, 11 November 2002.

"What's Left", *The New Yorker*, 16–23 February 2004.

MUSIC HISTORY
The Rag-Time Ephemeralist, number 1, self-published, Chicago, 1998.

The Rag-Time Ephemeralist, number 2, self-published, Chicago, 1999.

The Rag-Time Ephemeralist, number 3, self-published, Chicago, 2001.

TOYS, GAMES AND CARDS
Invitation, The Art Directors Club, Inc., 2 November 1994.

"Bat-Man Non-Posable Model Character Toy", and "Certificate of Authenticity", *Batman Collected* by Chip Kidd, New York: Bulfinch Press, 1996.

Flying exercise disc, Chicago Comics, 1997.

Wedding announcement, Franklin Christenson Ware and Marnie Christenson Ware, 4 October 1997.

"This American Life Amateur Secret Radio Decoder Outfit", WBEZ public radio, Chicago, 2000.

"Fairy Tale Road Rage", *Little Lit: Folklore & Fairy Tale Funnies*, New York: RAW Junior/Joanna Cotler/HarperCollins, 2000.

"Rusty Brown" lunch box, Dark Horse Comics, 2001.

"Fine Art Display Collectible Item" statuette (a.k.a. "Chicago Hero"), Chicago Comics, 2002.

"Help Jay & Christine Rocket Their Way to Nuptial Bliss," Wedding announcement, Mary Christine Domingo and James Rocko Doering, 2002.

"Jimmy Corrigan Vital Animus" vinyl figurine, PressPop Gallery, Tokyo, 2002.

"Quimby the Mouse", wooden toy with 32-page hardcover booklet, Dark Horse Comics, 2004.

POSTERS
Adult Entertainment and Love Jones, 1993.

The Cardigan Festival, 1993.

Adult Entertainment, 1994.

The Cardigan Festival, 1994.

The Cardigan Festival, 1995.

The Holland Animation Film Festival, 1996.

The Chicago Underground Film Festival, 1997.

Andrew Bird's Bowl of Fire and the Et Cetera String Band, 1998.

Jimmy Corrigan, The Smartest Kid on Earth, 2000.

The Whitney Biennial, 2002.

The Jack Hanley Gallery, 2003.

"This American Life" Lost in America tour, 2003.

BOOK, MAGAZINE AND CATALOGUE COVERS
Pictopia no. 3, Seattle: Fantagraphics Books, 1992.

American Illustration no. 14, New York: Amilus Incorporated, 1995.

Blab! no. 8, Northampton Massachusetts: Kitchen Sink Press, 1995.

The Duplex Planet Illustrated no. 15, Seattle: Fantagraphics Books, 1995.

The Comics Journal no. 200, 1997.

Print no. 51, 1997.

The New Yorker (with Chip Kidd), 21 and 28 June 1999.

The Newall Manufacturing Company catalogue, Chicago: The Newall Manufacturing Company, 1999.

Strapazin no. 57, 4 December 1999.

Pantheon Books summer catalogue, New York: Pantheon Books, 2000.

The New Yorker, 27 November 2000.

Drawn & Quarterly vol. 3, Montreal: Drawn & Quarterly, 2000.

The New York Times Book Review, 3 June 2001.

"Untold Tales of Kavalier & Clay", enclosed booklet cover in *McSweeney's* no. 7, 2001.

The Cartoon Music Book, Chicago: Chicago Review Press, 2002.

Out of Sight: The Rise of African-American Popular Music, 1889–1895, Jackson, Mississippi: University Press of Mississippi, 2003.

Michael Chabon Presents: The Amazing Adventures of the Escapist Vol. 1, Milwaukie Oregon: Dark Horse Comics, 2004.

BOOK DESIGN
Blackbeard, Bill (ed.), *Krazy & Ignatz 1925–1926*, Seattle: Fantagraphics Books, 2002.

Blackbeard, Bill (ed.), *Krazy & Ignatz 1927–1928*, Seattle: Fantagraphics Books, 2002.

Blackbeard, Bill (ed.), *Krazy & Ignatz 1929–1930*, Seattle: Fantagraphics Books, 2003.

Blackbeard, Bill and Ataker, Derya (eds.), *Krazy & Ignatz 1931–1932*, Seattle: Fantagraphics Books, 2004.

Selected Bibliography

BOOK DESIGN AND EDITING
McSweeney's no. 13, 2004.

Heer, Jeet and Oliveros, Chris (eds.), *Walt & Skeezix*, Montreal: Drawn & Quarterly, 2004.

RECORD ALBUM DESIGN
"Waiting on the Eclipse" b/w "Summer Salt", 5ive Style, Sub Pop Records, 1995.

A Gesture Of Kindness, The Karl Hendricks Trio, Fiasco Records, 1995.

Manhattan Minuet, The Beau Hunks Sextette, Basta Records, 1996.

The Ernie Kovacs Record Collection, Ernie Kovacs, Varèse Sarabande Records, 1997.

Virginia's Favorites, Virginia Tichenor, Pianomania, 1998.

Euphonic Sounds, Reginald Robinson, Delmark Records, 1998.

Joseph F. Lamb: The Complete Stark Rags, Guido Nielsen, Basta Records, 1998.

Lies, Sissies, and Fiascoes: The Best of This American Life, WBEZ public radio, Rhino Records, 1999.

Oh! The Grandeur, Andrew Bird's Bowl of Fire, Rykodisc, 1999.

Family album, The Tichenor Family Trio, Ragophile, 2000.

James Scott: The Complete Works, 1903–1922, Guido Nielsen, Basta Records, 2001.

More Candy, The Paragon Ragtime Orchestra, Rialto records, 2001.

Scott Joplin: The Complete Rags, Marches, Waltzes & Songs, Guido Nielsen, Basta Records, 2004.

SHEET MUSIC DESIGN
"Lake Street", Reginald Robinson and Frank Youngwerth, Chicago, 1999.

SHOPFRONT DESIGN
Signage for Quimby's Queer Store, Chicago, 1996.

Mural for 826 Valencia, San Francisco, 2002.

RETAIL DESIGN
Display stand for *The Acme Novelty Library*, Fantagraphics Books, 1998.

Display stand for *Jimmy Corrigan, The Smartest Kid on Earth*, Pantheon, 2000.

WEB DESIGN
The Rag-time Ephemeralist [http://home.earthlink.net/~ephemeralist/]

EROTICA
Alone Every Day, Bonus, Donut Sissy, European "Naked" Robot, Ham Operator, Pale Effete Shred of a Man, Stuffed Onion, and various other "jam" chapbooks, self-published with Dan Clowes, Gary Leib and Terry LaBan, Chicago, 1992–1994.

Articles about Chris Ware

Arnold, Andrew, "Q and A with Comic Book Master Chris Ware", time.com, 1 September 2000. [http://www.time.com/time/nation/article/0,8599,53887,00.html]

Arnold, Andrew, "The Depressing Joy of Chris Ware," time.com, 27 November 2001. [http://www.time.com/time/columnist/arnold/article/0,9565,185722,00.html]

Arnold, Andrew, "A Mouse; A House; A Mystery," time.com, 22 August 2003. [http://www.time.com/time/columnist/arnold/article/0,9565,477842,00.html]

Brockes, Emma, "'I Still Have Overwhelming Doubt about My Ability,'" *The Guardian*, 7 December 2001. [http://books.guardian.co.uk/Print/0,3858,4315150,00.html]

Eggers, Dave, "After Wham! Pow! Shazam!" *The New York Times Book Review*, 26 November 2000, pp. 10–11.

Groth, Gary, "Understanding (Chris Ware's) Comics", *The Comics Journal*, no. 200, 1997, pp. 119–178.

Heller, Steven, "Smartest Letterer on the Planet", *Eye*, no. 45, vol. 12, Autumn 2002, pp. 18–25.

Hignite, Todd, "Chris Ware: In the Studio", *Comic Art*, no. 3, July 2003, pp. 4–13.

Huestis, Peter, "Chris Ware: Comics' Acme", *Hypno Magazine*, vol. 4, no. 8, 1995, pp. 4–9.

Juno, Andrea, "Chris Ware", *Dangerous Drawings: Interviews with Comix and Graphix Artists*, Juno Books, New York, 1997, pp. 32–53.

Katz, Alyssa, "Lost Horizons: Chris Ware's Vintage Point", *Voice Literary Supplement*, June 1998, p. 19.

Kelly, Dan, "Of Mice and Men and Cat Heads Too", *Chum*, no. 1, 1994, pp. 14–20

Kidd, Chip, "Please Don't Hate Him", *Print*, no. 51.3, 1997, pp. 42–50.

Lanier, Chris, "Brain Child", *San Francisco Chronicle*, 26 November 2000.

Levi, Jonathan, "Jimmy, We Hardly Knew You", *Los Angeles Times Book Review*, 31 December 2000.

Murray, Noel, "Cat and Mouse", *The Onion AV Club*, vol. 39, no. 29, 31 July–6 August 2003, p. 33.

Nadel, Daniel, "Jimmy Corrigan, The Smartest Kid on Earth", *Graphis*, no. 57, May–June 2001, p. 13.

Nissen, Beth, "Transcript: An Interview with Chris Ware", cnn.com, 3 October 2000. [http://edition.cnn.com/2000/books/news/10/03/chris.ware.qanda/]

Nissen, Beth, "A Not-So-Comic Comic Book", cnn.com, 3 October 2000. [http://edition.cnn.com/2000/books/news/10/03/chris.ware/index.html]

Phipps, Keith, "Chris Ware", *The Onion A.V. Club*, vol. 37, no. 16, 3–9 May 2001, pp. 17–20.

Poniewozik, James, "Right Way, Corrigan", *Time*, vol. 156, no. 11, 11 September 2000.

Raeburn, Daniel, "The Smartest Cartoonist on Earth", *The Imp*, no. 3, 1999, pp. 1–20.

Ryan, Mo, "Chris Ware: Purveyor of Comics, Jokes, Tricks, Novelties and Assorted Laff-Getting Sundries", *Steve Albini Thinks We Suck*, no. 8, October 1996, pp. 6–9.

Sabin, Roger, "Not Just Superheroes", *Speak*, no. 6, Summer 1997, pp. 39–41.

Silverblatt, Michael, "Small Wonders", *BookForum*, Winter 2000.

Strauss, Neil, "Creating Literature, One Comic Book at a Time", *The New York Times*, 4 April 2001, pp. B1–B7.

Tolentino, Noël, "Chris Ware of The Acme Novelty Library", *Bunnyhop*, no. 9, 1998, pp. 93–95, 126.

Williams, Dylan, "An Interview with Chris Ware", *Destroy All Comics*, no. 1, 1994, pp. 8–19.